KOKOSCHKA'S DOLL

Also by Afonso Cruz in English translation

The Books that Devoured My Father (2020)

AFONSO CRUZ

Kokoschka's Doll

Translated from the Portuguese
by Rahul Bery

MACLEHOSE PRESS
QUERCUS · LONDON

First published in Portuguese as *A Boneca de Kokoschka*
by Quetzal Editores, Lisbon, 2010

First published in Great Britain in 2021 by

MacLehose Press
An imprint of Quercus Publishing Ltd
Carmelite House
50 Victoria Embankment
London EC4Y 0DZ

An Hachette UK company

Co-funded by the
Creative Europe Programme
of the European Union

This publication has been funded with support from the
European Commission. This publication reflects the views only of
the author, and the Commission cannot be held responsible for any
use which may be made of the information contained within.

A CIP catalogue record for this book is available from the British Library.

ISBN (TPB) 978 1 52940 269 8
ISBN (Ebook) 978 1 52940 270 4

2 4 6 8 10 9 7 5 3 1

Designed and typeset in Scala by Patty Rennie
Printed and bound in Great Britain by Clays Ltd, Elcograf S.p.A.

MIX
Paper from
responsible sources
FSC® C104740
www.fsc.org

Papers used by Quercus Books are from well-managed
forests and other responsible sources.

The most wretched illnesses can turn our bodies
into birdcages for the soul. Parkinson-plus is one of
the most perverse ways in which the Universe shows
off its medieval cruelty. Or, as Lao Tse put it,
the Universe treats us like straw dogs.

—

THIS BOOK IS DEDICATED TO MY MOTHER

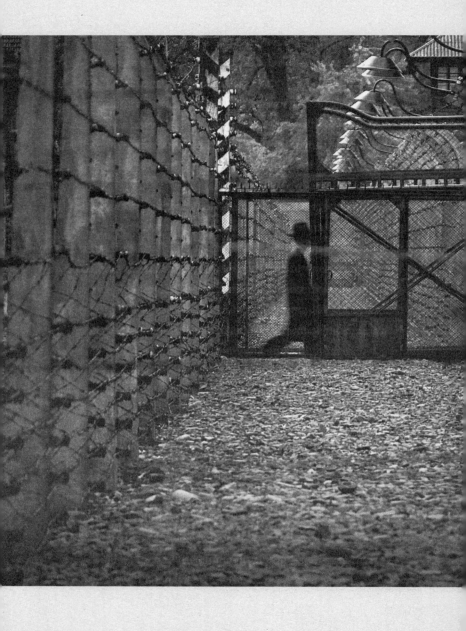

Part One

The voice that comes from the earth

At the age of forty-two, or, to be precise, two days after his birthday that year, Bonifaz Vogel began to hear a voice. Initially, he thought it was the mice. Then he thought about calling someone to deal with the woodworm, but something stopped him. Perhaps it was the way the voice had given him orders, with the authority of those voices that live deep inside us. He knew it was all in his head, but he had the strange sensation that the words were coming from the floorboards, entering him through his feet. They came from the depths, filling the bird shop. Bonifaz Vogel always wore sandals, even in winter, and he felt the words slipping in through his yellowed toenails and his toes, which curled from the impact of entire sentences smashing into the balls of his feet, then climbing up his white, bony legs and making their way into his head through his hat. On several occasions he tried taking it off for a few seconds, but this always made him feel undressed.

Bonifaz Vogel's soft, soft, white, white hair was always

combed and always covered by a felt hat (which he alter-
nated in summer with another, cooler hat).

He spent his days sitting in a wicker chair which an
uncle had brought him from Italy.

The *Duce* had once sat in it, his uncle had told him.

The day he received the chair as a birthday present,
Bonifaz Vogel sat down in it. He liked it, found it comfort-
able; it was a nice piece of furniture, with strong legs. He
picked it up and carried it above his head to the bird shop.
A parrot whistled as he walked past, and Vogel smiled at
it. He placed the chair next to the canaries and sat down
beneath their chirping, which filled the empty spaces in
his head. When the birds were singing loudly, Bonifaz
Vogel would stay completely still, afraid that if he got up
his head would collide with the pretty chirping.

He was afraid of
breaking the pretty
chirping

He left his friend's head an eternity behind

Isaac Dresner was playing with his best friend Pearlman when a German soldier appeared, between a corner and the ball hitting the crossbar. The soldier had a gun in his hand and emptied a bullet into Pearlman's head. The boy fell face down onto Isaac Dresner's right boot. The soldier looked at him for a few seconds. He was nervous, sweating. His uniform was impeccably clean, its colour very close to that of death, with black, gold, white and red insignias. On his rectilinear, yellowy-white neck one could clearly make out two blue, impeccably Nazi arteries, glistening with sweat. The colour of the soldier's eyes was not visible because they were half-closed. His solid trunk moved up and down, struggling to breathe. The man pointed the gun at Isaac Dresner but the weapon remained silent, it did not fire: it was jammed. Pearlman's head rolled off Isaac's boot and onto the ground at an impossible, abstract angle, making a strange noise as it hit the street. It was an almost inaudible sound, the kind that is deafening.

The following things were entering Dresner's ears:

1: The soldier's breathing.
2: The sound of the Mauser not firing.
3: The almost inaudible sound of his best friend
 Pearlman's head sliding off his right boot and hitting
 the ground.

Isaac ran down the street on his spindly legs, leaving his friend's head behind (an eternity behind). The soldier aimed the weapon again and fired. He missed Isaac, who was running, his boots soaked in blood and defunct memories. Three bullets whistled right past Isaac Dresner's soul, hitting the ghetto walls instead.

Despite being left a whole eternity behind him, Pearlman's head remained forever chained to Isaac's right foot, by the iron chain that fastens one person to another. That was why he limped slightly and would do so for the rest of his life. Fifty years later, Isaac Dresner would still be dragging the weight of that distant head around with his right foot.

Isaac kept running, dodging the fate that was whistling alongside him

Isaac kept running, dodging the fate that was whistling alongside him. He turned several corners, leaving the soldier behind, and entered the bird shop belonging to Bonifaz Vogel, where his father had built a cellar some years earlier. Isaac had been present and had watched that dark space growing beneath the earth. At the time, he had realised that:

The construction of buildings was not only a matter of piles of bricks and stones and tiles; it was also empty spaces, the nothingness which grows inside things like stomachs.

Panting, Isaac opened the trapdoor – without Bonifaz Vogel noticing – and entered like water through a drain. He stayed there for two days, only coming out at night to drink water from the birds' drinking fountain (he hadn't seen the tap, despite it being right in front of him) and eat birdseed. By the third day, he couldn't take it anymore:

"Please, Mr Vogel, bring me something to eat. And a chamber pot."

Sitting in his wicker chair, Bonifaz Vogel pricked up his ears. He was hearing voices. That was the moment he began hearing voices. The sound entered him between his legs and trousers and by the time it reached his ears it had a childlike timbre, like a cat when it is called, zigzagging between things. Isaac Dresner repeated his request – the second time around it was almost an order – and Vogel got up to go and look for food. Isaac told him to put the tray by the counter. That night he was pleased to see a bowl of porridge and some sweets. There was a chamber pot too.

Bonifaz was like a
GLASS
in an elephant shop

Sitting in a wicker chair with the war all around him, Bonifaz Vogel was like a glass in an elephant shop

The little – and invisible – Jew ended up living in that dark cellar beneath the floorboards, becoming nothing more than a voice. Bonifaz Vogel lived with the words which spoke to him through the floor of his bird shop.

Mr Vogel, it would say, put some sweets on the floor, next to the counter, under the shelf where you keep the birdseed. And he did just that. He would crouch down and carefully deposit some sweets on top of the packing paper in the location indicated, along with the thoroughly cleaned bedpan. He would emit a plea, just a wordless whisper, with that intimacy prayers have. And then he would bless himself, staying there for a few solemn seconds as he looked at the sweets.

One day, he took the initiative of adding some cuttlefish bones, the kind he gave to the birds, but the voice did not like them.

The horizon on the other side of the street

Every morning, Bonifaz Vogel woke up very early and, with machine-like precision, dressed, combed his hair and put on his hat. He always wore a hat: he had one made of felt and another made of straw (for the summer). Bonifaz Vogel often said it was the same kind of straw his chair was made of, the one that had helped to prop up a dictator. He ate some bread and drank some tea. Then he headed straight to the shop, with his soft hair, all white like a seagull's breast, and his hands either in his pockets or holding on to his grey or brown braces. He pulled the bunch of keys from his jacket's outside pocket and opened the street door, flipping the sign which read CLOSED and transforming it into the sign which read OPEN. Then he gave a sort of Nazi salute, regardless of whether the street was deserted, or whether the street was full. He looked in his enormous bunch for the smallest key, which was very rusty but still worked, and opened the cupboard where he kept the mop and bleach. He filled a bucket with water

behind the counter and began to clean the shop. This activity took up the whole morning: he washed all the cages, the floor and the walls. He did it meticulously, as if he himself were taking a bath. He cleaned every one of the shop's folds, its armpits, its groin and its less visible regions. Sometimes he stopped to rest, which meant sitting very still beneath the chirping of the canaries. His eyes remained glued to the horizon which, for him, was just on the other side of the street.

Birds in disguise

"Schwab is a crook," Isaac stated. "He's selling you sparrows that have been painted yellow, Mr Vogel. They're not canaries."

Bonifaz Vogel shrugged. His head, a German teacher had once told him, was made up of cranial ellipses. From the day of the painted birds onwards, Isaac Dresner started helping him with his business.

If Vogel was unsure about the price of society finches, for example, he would go behind the counter, crouch down (where the client could no longer see him), press his ear to the floor and whisper something, as if he were talking to someone. Then he would stand up straight, brush the dust from his trousers and repeat in his own voice whatever the voice had whispered to him. People found this behaviour perfectly normal, indeed they expected nothing less from Vogel, a man full of cranial ellipses. He would give one price and the client would give another; then, if necessary, he would crouch down one more time, down to the

floor where the voice told him things through the cracks between the floorboards. He would get up again, brush the dust from his knees and, with an irresistible price, the business would draw to a close. As the client walked away, Vogel would lean against the shop door, visibly tired from hearing voices, his ear red from being pressed against the floor. Then, very slowly, he would count whatever notes the birds had yielded him. He had never asked himself why people were buying society finches during wartime.

Cranial ellipses

Because he was sweating, it was hot

Isaac did not understand Bonifaz Vogel: he was a mature
man who owned a bird shop and almost three hats, and
yet he was like a child, a suspicious child. Isaac Dresner
told him tales of Rabbi Nachman of Breslov to see if he
was capable of learning anything, but Bonifaz Vogel's
head was made up of cranial ellipses. He was a man with
no future and no past. Time went through him like bath
water. Past and future were not linear concepts to him;
there was no past/future arrow the way there is for most
of us. Often, when Bonifaz sweated, it wasn't because of
the heat, but because it was hot. That makes all the differ-
ence. Other times, he saw not causal relationships but
simultaneity in things. And yet there were other occa-
sions when he saw time the opposite way around, like a
shirt that has been put on backwards: he'd say it was hot
because he was sweating. His sweat was what caused the
heat. His relationship with the world and with time could
be experienced in three ways: a) he sweated when it was

hot, without there being any causal relationship, they were simply simultaneous; b) he sweated because it was hot (which happens to be the system we normally use to interpret phenomena which occur around us, that is, the cause/effect explanation); and c) because he was sweating, it was hot (a way of looking at things of which Aristotle would not have approved).

O

Bonifaz Vogel mostly breathed through his mouth, which was why it was always open. Like the letter "o", or to be more accurate, like a big letter "o":

People told him he was stupid, and he would stroke his chin and nod in agreement. All the people around him possessed reason and he was an island in the middle of all that rationality, a hyphen between two words, a missing link. Deep down, the evolution of every species is maintained by hyphens, by links both missing and found. And Bonifaz Vogel was an island sitting in a wicker chair where the *Duce* had once sat.

The Universe is a combination of letters

The voice that Bonifaz Vogel heard coming up from the ground, like weeds, told him many things. Isaac Dresner would hold his mouth against the cellar ceiling and let the thickest sentences squeeze through the cracks in the floorboards and spread out into the bird shop before they came to a halt in Bonifaz Vogel's body.

"There was a beggar," the words that were being strained through the cracks said, "whose prayers were always answered. On seeing that this was the case, a rabbi asked him how he did it. How was it possible that all of his prayers were answered? The beggar told the rabbi that he could not read or write, so he just recited the alphabet, simply saying the letters one after another, and asked the Eternal to organise them in the best possible way."

After each story Bonifaz Vogel would rub his ear and show no sign of having understood, but when he heard that anecdote, he began praying with letters only, with no words or whispers. His prayers became the alphabet. To

make each prayer more effective, Isaac had taught him how to say the twenty-two letters of the Hebrew alphabet.

"It's best to speak to Adonai in His own language," Isaac Dresner told him, "which, as everyone knows, is Hebrew. That way you avoid unfaithful translations."

And, Isaac assured him from under the floorboards, those twenty-two letters were all that was needed. God would do the rest. What He does up there is play Scrabble. People give him some letters, thinking they know what they want, but they don't know, and so God reorganises all the tiles and makes new words. It all boils down to a parlour game.

And, as you can see from all the bombs falling out there, God is not much of a player.

Luftwaffe

Sometimes, sitting in his wicker chair, Bonifaz Vogel would cry. His family had never been big, but now it had disappeared completely. Helmer, who had been his uncle, Lutz, who had been his father, Karl, who had been his cousin, and Anne, who had been his mother, had died in the bombing and now all he had was the bird shop.

Anne Vogel was all mother, highly protective. Bonifaz spent many an hour sitting with his back straight, his mouth open and his hands resting on his knees, watching his mother do the housework. Anne Vogel always had her hair tied up and an innocent look about her, as if wars did not exist. Lutz Vogel, Bonifaz's father, had the exact opposite appearance: cruel lips and eyes and small ears, canine-like in the way they emerged from his head, with no lobes at all. Bonifaz liked that martial face, the way it crowned his pot-bellied body, a body that enjoyed wheat beer and dishing out kicks to close family members.

Lutz Vogel exploded while smoking a cigar on his

living-room sofa (on October 7, 1944), along with his wife and brother. Around seventy tonnes of bombs had fallen that day. Bonifaz did not die on that date because he wasn't at home, just like his cousin Karl, who also did not succumb under the weight of those bombs: Karl had died a year earlier, during the battle of Stalingrad.

Bonifaz's uncle, Helmer Vogel, was a big man, bigger than his brother, with a bigger pot-belly and with even crueller features. But his behaviour was totally different; he was very sentimental and gentle, to the extent that he actually liked his nephew and showed some affection towards him. Helmer Vogel would often remove Bonifaz's hat and ruffle his hair. One day he even gave him a chair.

Helmer (1903–44)
Anne (1874–1944)
Lutz (1867–1944)
Karl (1908–43)

His fat cat, Luftwaffe, also perished in the explosions,

Luftwaffe (1935–44)

which was a great loss for Vogel. He always used to sleep with it, and their relationship was one of equals. Sometimes he would stroke it so forcefully that the cat would moan in pain. Bonifaz enjoyed squeezing it, but

he never caused any serious harm because Anne Vogel always intervened. He had moments of great excitement and commotion, involving people around him or cats or friends or visitors. He would grip Luftwaffe with his stealthy hands and hug the cat with his entire German body. It would try to escape, baring its claws and teeth, until Bonifaz's mother saved it from that excess of love. Anne Vogel would tell him to take care: love can really hurt. Others may die, but we're the ones who suffer.

When the building in which he lived with his family exploded, Bonifaz moved to the room above the bird shop. It was a small, perfectly functional apartment, which he used as an office. Bonifaz's mother was absolutely right.

Luftwaffe

Bonifaz Vogel lived in the
midst of metaphors

Bird shops contain the highest concentration of bird-cages. Bird shops are built with more restrictions than anywhere in the world. There are birdcages every-where, and some of them are not outside the birds, as people would imagine, but inside them. For Bonifaz Vogel had often left the doors of the cages open with-out the canaries escaping. The canaries stayed where they were, cowering in the corner, trying to avoid look-ing at that open door, turning their eyes away from freedom, one of the most terrifying doors that exists. They could only feel free inside a prison. The cage was inside them. The other one, the one made of metal or wood, was just a metaphor. Bonifaz Vogel lived in the midst of metaphors.

Vogel would sit and watch those birds and think about his family, which had exploded along with the Persian rugs in the living room and the cuckoo clock. Where were

they now? Isaac Dresner would talk about God from his cellar beneath the wooden floor, and Bonifaz Vogel did not understand what motive God could have had for wanting his cousin Karl by His side. Nor could Isaac Dresner explain the cuckoo clock. If some go to the great unknown then where do cuckoo clocks go?

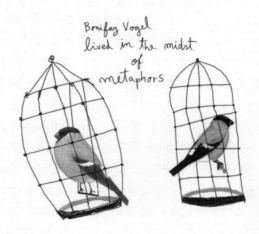

Bonifaz Vogel
lived in the midst
of
metaphors

The tears fell down the different faces he made on his wicker chair and the voice came up through his legs, telling him the story of the beggar who prayed the alphabet.

Bonifaz Vogel prayed like this:

Alef, bet, gimel, dalet, he, vav, zayin, chet, tet, yod, kaf,
lamed, meme, nun, samekh, ayin, pay, tsade, qof, resh,

shin, tav.
Amen.

His body would rock back and forth and he would stop
only when a client placed a hand on his shoulder to ask
him the price of the cockatoos. Even so, Bonifaz Vogel
would recite the alphabet to the end, in case God noticed
that certain letters were missing. Then he would tell them
the price of the cockatoos. The client would try to hag-
gle and he would crouch down, push his ear against the
wooden floor behind the counter and listen to the voice.
It looked as if Vogel was doing some kind of contorted
prostration, before rising again with a counteroffer as he
wiped the dust from his knees. Even as the bombs came
down, some people still wanted cockatoos.

The door to Paradise is the neck of a jar

Every day, Vogel would put food behind the counter, fol-
lowing the voice's orders. He would put down a dish of
vegetable soup – sometimes only nettles and borage were
available – rice, bread, fruit and sweets. Once the shop was
closed and in darkness, Isaac Dresner would leave his hid-
ing place to eat. There were always some sweets, because
the bombs had missed the jar where Vogel's mother used
to keep them. The jar had escaped unharmed on a kitchen
counter where there had also been a small aquarium. The
tiny red fish had not survived the war, but the heavy, stout
jar with a white lid had been luckier.

"The door to Paradise is the neck of a jar," Isaac said.
"That's what my father used to tell me: the neck of a jar.
You know why, Mr Vogel? Because of monkeys. Imagine
a jar full of walnuts. The monkey has no difficulty putting
his hand in there, but once he has grabbed the walnuts,
he can't get it out again. He must leave the walnuts
behind in order to free himself. And Paradise is just like

that: we must leave the walnuts behind and show our empty hands."

"We must leave the walnuts behind," Bonifaz Vogel said.

"Exactly. The walnuts are what stop us being free. They are our birdcages, Mr Vogel."

In other words, *The Book of Exodus*

Influenced by the darkness, Isaac Dresner would recite the Torah (because, he said, it was the only light he had), reciting it as much as he could, using his memory to say the words in the Torah exactly as they had been written down, without altering so much as a comma. In this instance, it was Exodus:

"Pharaoh oppressed the Israelites and put them in the fields to work, forcing them to build cities called Pithom and Rameses. These big, invisible cities had come to Pharaoh in a dream. In the dream, he perceived that he was under threat and ordered all the new-borns of the Israelites to be tossed into the river, because he feared for his throne. Pharaoh's enemy was created in a dream. If Pharaoh had not dreamed of Moses, he would not have been abandoned in the river and he would not have become Moses. Have you ever heard of Oedipus, Mr Vogel? He also created the future through his own confused dreams. Another thing Pharaoh did not know, but

which we must all know, is that our enemies are nei-
ther the new-borns of the Israelites nor anyone else who
is outside us. The proof of this is that, when Moses was
abandoned to the waters, it was Pharaoh's wife who found
him and raised him and adopted him as her own son.
The enemy lives in our homes and what we most fear, the
thing that threatens us the most, is precisely that which is
closest to us (inside us, inside this house that is our body),
that which we raise, feed and educate, to which we tell
stories and give food and drink. For that is what we do to
our vices, Mr Vogel, our vices. Do you follow? There is no
point going in search of Evil outside of ourselves. We have
to look within, and that is very easily done: if we open our
eyes to see what is outside, then in order to see what is
inside, we must shut them tight."

"We close them not to sleep, but to see," Bonifaz Vogel
said.

"Exactly, Mr Vogel. To see. But let us proceed: one
day, Moses killed an Egyptian when he thought no-one
was looking. But the Eternal is always looking, His eyes
are closed and looking inward, for all that exists, exists
within Him. He sees things with His eyes closed and
we are the space between the dream and the nightmare.
What the Eternal does not see does not exist. Science has
shown this to be beyond doubt. Blue dogs, like poems, do
not exist, because no-one has ever seen a blue dog. If, one
day, someone did see a blue dog, then blue dogs would

exist. All this is perfectly scientific. But on we go with the story: Moses had to flee. He was not fleeing Pharaoh, but himself. The text says it was Pharaoh who persecuted him, but it also says that, at the time of the offence, no-one was around to see it. Now, if no-one was around to see it, Moses could only have been persecuted by his conscience, the most efficient Pharaoh in the whole of our own Egypt. And so, Moses went to live with Jethro, a priest of Midian who lived in the desert. And that is where every man who is being persecuted by Pharaoh goes. He goes to a place where there is no-one around except for his despair and his personal Pharaoh. The desert is not a place of sand, but a place of guilt. So Moses married Jethro's daughter, who was called Zipporah. One day, while tending Jethro's sheep, he saw the Eternal as a bush that burned without being consumed. The exact opposite of men, whose souls consume their bodies until they are extinguished; for the body, my father used to say, is a wooden log and the soul is the fire coming off the trunk. There, in that bush, was eternity defined as such: a fire that needs no fuel. Everything in the Universe is dependent on everything else and nothing is independent. Except for that fire, which needed nothing else in order to exist. Moses stood and admired it and the Eternal told him to take his shoes off. He did so. And then He said: 'I am the Lord of Abraham, Isaac and Jacob.' Note, Mr Vogel, how He didn't just say that He was the Lord. He said it like that, in a more complicated way, naming

all those people to show that, despite all of them having seen Him in different ways, He is One. Abraham saw one thing, Isaac another, Jacob yet another. But the object of their vision was the same. He could have simply said that He was who He was and nothing more, but instead He listed the patriarchs, as if needing to justify Himself. Now from the bush there came a voice like falling bombs, which sounded as if it were coming from the ground, from a cellar. And it criticised the Egyptians, who were mistreating the Israelites, forcing them to build invisible cities made from the vapour of their bodies. In short, He entrusted Moses with freeing that oppressed people. And those people were like the birds in this shop. When the doors of their cells are opened, they do not take flight, but cling to the bars instead. Moses wanted to carry his people off, free them, but they did not want this. That shackled, enslaved people said that all was well, that they had food and that was enough. They said it with their bodies covered in chains and their souls covered in chains. Moses practically had to force them, listening to their complaints every day. Why is it that Moses took forty years to cross a region that can be traversed in a week? Because the Promised Land was not a physical location and Moses wanted them to understand that the Promised Land is a journey, it is a land located wherever the man who desires it is. The Israelites carried the Land within themselves on their journey; they themselves were the Land as they wandered

through the desert. But they did not understand, and at the end of those forty years, Moses gave up. He resolved to give them a land that was not the Promised Land, which is not on a map or at any given geographical point but wherever men are. That is why the Eternal wanted Moses to die before setting foot in that land. It was a final message for the people: you can only walk in this Land with your soul, not with your feet. Moses was the only one to set foot in the true Land; the others were walking in an illusion.

Moses was every mother

Whenever he told the story of Exodus, Isaac would consider another interpretation of the death of Moses:

Moses is like my mother. He died before he saw the Promised Land, she died before she could watch me grow and bear fruit. Now I'm under the soil like a seed, but one day I shall surely grow. I clearly remember her eyes, made completely of tears, looking at me through the torment of knowing that she would not live to see the most beautiful thing in the world, me, grow. But what can be done about typhoid fever? And that is the story of Moses. Moses was every mother.

Only the space of the open mouth remained

Isaac Dresner said that he was a cricket while he, Bonifaz Vogel, was a wooden doll. A golem, Isaac Dresner said, a golem.

"You know, Mr Vogel, I always wanted to have a golem, an artificial man. A friend, basically. Once I tried to make one out of mud. I shaped it and set its height (it had to fit under my bed). Then I opened its mouth and wrote the name of the Eternal there. It stayed like that, Mr Vogel, his mouth wide open just like yours, awestruck by the taste of the Name. I gave it two fisheyes for its eyes, but later I swapped them for ball bearings from my father's office. I drew two lines on its trunk, dividing the golem into three parts: the head, the thorax and the stomach. I wrote the letter *shin* on its head, the letter *alef* on its thorax and the letter *mem* on its stomach. The first is Fire, the second Air and the third Water. The reason behind this was written down in the *Sefer Yetzirah* and in Nature which is all around us. Water descends, that is why it goes below,

in the stomach and the entrails of the Earth. Air is in the thorax, it's all around us, and Fire is in the head. Because fire always rises, it is the opposite of water. They cannot see each other; they need air in the middle. The other children had dolls that they dressed and undressed, with blonde hair, blue eyes and paper bodies, while I had a man made of mud, with arms made of earth and a head made of earth and a trunk made of earth, with Hebrew letters written all over its body and lines uniting and separating them. But the homunculus would not speak to me, not even to say yes or no, despite seeming to want to with that open mouth. I could see it hesitating whenever I looked at it. I was certain that the Name had spread throughout the mud, drenching it. Therefore I didn't understand why it didn't move like we do. I felt bad for it, with the Word held prisoner inside its naked body. I began to lose hope that it would eventually come out from under the bed and start telling stories about Rabbi Nachman. So one day I pulled the mud apart, separated the arms, legs and head, divided up the trunk and erased all the letters from its skin. Only the space of the open mouth remained, a very big 'o'. It was like this war: Humanity torn to shreds, and all that's left is the wonder of an open mouth."

The living grew deader and deader

Three to four thousand tonnes of bombs fell between February 13 and 15, 1945, far more than in October of the previous year, during the bombardments that hit Bonifaz Vogel's family. Dresden was undone over those February days. There was one bomb for every two inhabitants, with the centre reaching more than one thousand five hundred degrees centigrade. The fire spread throughout the city, its arms open wide and its slender fingers entering everywhere, through closed doors, through high, barred windows, through even the most virtuous bodies. The living grew deader and deader; there were thousands and thousands of civilians spread all over the ground and the air, bodies ripped apart and divided into bits, into useless pieces. A puzzle for God. He would have to gather together all the teeth embedded in the walls – the canines, the molars, the incisors – along with all the bones, planted in the ground like irrevocable, definitive flags. Kilometres of pieces that were difficult to fit together, an immense

jigsaw with fascist levels of difficulty. Some bodies had been shrunken by the fire, and where they had once been full-bodied and blond-haired, now they were the size of newborns, white as milk and rolled in concentric circles around themselves. Fire turns things black, but when it is allowed to persist they end up white. The sirens continued to ring out.

"Life is built from dead pieces," Isaac Dresner said. "A series of lifeless things, when placed together, make a living being. We join molecules together and a cell appears. That is the work of the Eternal: to join dead things together in order to make living things. We join deaths to deaths until the impossible occurs. It's like rubbing two dead twigs together and making fire (which is just twigs brought to life)."

In which joint does a child's smile fit?

And then there are the memories, shattered and stuck in the walls, and far harder to interpret than arms are. A left arm is a left arm, but a feeling is more elusive. "In which joint does a child's smile fit?" God wonders as He rebuilds man for the Resurrection. Some memories do not fit in the body. A child's smile is a puzzle piece larger than the puzzle it belongs to. And Dresden was not only pieces of cement and bones but of souls, a mess of spirit and matter, a most un-Cartesian soup.

"Dresden is a puzzle," Isaac Dresner said, "made of infinite shards, innumerable pieces."

The birds are damaged

Bonifaz Vogel looked out at the buildings and counted the intact windows. This amused him and he said the numbers out loud so that the Universe could hear.

The birds were mute. All silent in their cages.

"The birds are damaged," said Bonifaz Vogel.

"One cannot sing when the world has been unmade and turned to ash," said the voice.

"No-one will want to buy birds that sing silently."

"You are absolutely right, Mr Vogel, but what to do?"

"I know some songs. I must teach the birds to sing again."

Popa and Tsilia

1

The painting was almost finished and Tsilia began to get dressed. Her body was freezing, not from the cold (which was boundless, and reason enough), but from looking at her reflection in the mirror in Franz Ackerman's living room. The house was very big and had a huge fireplace. Three long windows opened out into the cold that was all around. The city was full of that cold and the noise of the aeroplanes.

The reflection Tsilia Kacev saw in the mirror was not a cold body but a life which resembled a cold body. After that moment of sadness and contemplation, she got dressed quickly. The green dress, which was in its death throes and beyond salvation, accentuated her skin colour, which had a red tone to it, giving her a strangely healthy glow. She took a few steps towards the painter and looked at the painting. It was abstract. Its gaze was abstract. Ackerman ran his hand through her hair.

"It's not my best work, but it's not bad at all. It has spirit. Look at the expression: doesn't it seem ambiguous to you, like the words of your Torah?"

Tsilia shrugged her shoulders.

"My nose is very different."

Franz Ackerman poured himself a glass of Schnapps and drank it all in one go.

"That's the way I see it. You see it one way and I see it another way. Thus we are all thousands of different bodies. Our bodies depend greatly on the gaze of others. If you could bring together all the differing opinions that exist about you, then you'd be getting very close to the way God sees things."

"When I look at the painting, I can't tell if I'm being portrayed from the side or straight on. I see my two breasts, which look like two eyes open very wide. It doesn't look real to me."

"You want to know what's not real? Painting things from just one angle. When I think about you, it's not only straight on, or only lying down, or only from behind or only walking. The truth has many perspectives. If we limit ourselves to one, then we're getting close to total error."

"My eyes look like two fish."

"That's because we see the world from inside an aquarium."

Tsilia threw herself against Franz Ackerman. She had no logical reason for doing so. Ackerman protected her and treated her like a human being. The painter fell, knocking over the table and causing the Schnapps bottle to fall onto the oil palette. Tsilia grabbed a coat. He looked at her, dumbstruck, his blue eyes wide open as he watched her leave through the front door. She won't go far, he thought.

Tsilia walked down the streets like a German, but with her arms crossed over her body because of the cold. She looked to the ground and saw her feet, her brown leather shoes, which emptied her mind of other thoughts. From time to time she looked up and never stopped, scared of seeming hesitant. She had to walk without stopping, as if she knew exactly where she was going.

When she got tired, she sat on a stone bench by the River Elbe. She was terribly hungry and felt like going back to Ackerman's house. She asked herself why she had left like that. Then the bombs began to fall (an almost uncountable four thousand tonnes of them). Tsilia's legs were trembling, and this made the ground tremble.

3

Mathias Popa picked up a piece of shattered glass. He gripped the glass so hard it made his hand bleed. The

soldier never understood what had happened. He fell to his knees before falling into the infinity of death, his neck opening up like a fish's gill. All of this happened with great serenity, as if he had not wanted to inconvenience the Universe. Popa took the Luger from the soldier's belt and attached it to his trousers. He spat over the still-breathing body, his saliva sliding down the right side of the dying soldier's face and slowly entering his mouth, which was wide open like a very big "O".

The soldier's eyes looked like two fish, Popa thought.

He left the storehouse in which he had been hiding for more than two months. He couldn't stay there. Cautiously, he made his way through a small wood. That night, still taking great care, he headed for the centre, because he was starving. He saw a patrol in the distance and went down to the river.

4

We see the world from inside an aquarium. We never see the sea, Tsilia thought. But that is because we live in Dresden. Tsilia intended to buy a blue bathrobe, to camouflage herself in the waters of the sea. All blue like a heavy sky fallen to earth. She would swim in that weighty, salty sky, a sky that had fallen to earth. The Torah says that there were once two waters, one above and one below. Two seas: one light and made of air, another heavy and made

of water. The fire was above. And in Dresden the fire was all around.

She got up from the stone bench on which she had sat, surrounded by the calamity, and started walking again. She went down some steps to the river and noticed a recess behind a tree. She pushed the leaves out of the way and entered the tight space. She lay down and fell asleep almost instantly.

In the middle of the night, she was woken by a sixteen-year-old boy called Mathias Popa. He had a Luger in his hand. Tsilia backed up against the wall, squeezing herself into that space.

"Shhh," he said.

And he lay down next to her. They stayed like that, both awake, not saying a word, until dawn broke. Throughout the morning they clung greedily to each other, naked, more from ennui than from any kind of passion which the circumstances might have induced. Nothing but moans left their lips, as if they were both mute. Their open mouths (like big "O"s) gasped, but they had no words to speak. When night came, Mathias Popa left. The bombs kept falling.

Isaac's eyes were dark, like extinguished light

The war was coming to an end after destroying everything: houses, love, cuckoo clocks. The voice ordered Bonifaz Vogel to open the trapdoor and a child rose up from the ground. Vogel was astonished, because the boy's father had built it and he could not remember anyone having been there at the time. How can a voice turn into a filthy child with such straight teeth?

Isaac Dresner was so nervous his knees were knocking against one another, and his sight was much diminished after months with no light. And yet the lifeless air had form and definition when compared with the debris of Dresden. His highly delicate feet made imprints on the ground that was laden with ashes and the remains of men.

Bonifaz Vogel was like a son to Isaac Dresner. A son whose memories meant that he could never sit him on his lap. But he was like a son. Officially, however, it was the other way around. When Isaac left the trapdoor – and

the shop – holding hands with Vogel (who had no idea what was happening), the soldier asked:

"Is he your son?"

"He's my father," Isaac said.

Vogel smiled without understanding and the soldier looked at the two of them, holding hands. There was a tear in his eye, steamed up in the fog of war.

Tsilia Kacev settled on those lives like the shadow of a bird

"What about her?" the soldier asked.

Isaac Dresner turned around and saw a girl with her head tilted to one side and a deep-set gaze. He had no idea who she was, but the way her lips were trembling was a call for help. She had appeared out of nothingness, like the shadow of a bird sitting at the table, walking without noticing she was walking. She was wearing a green dress and had her arms wrapped round her body to protect herself from the cold or perhaps so as not to let out the unbearable cold she was feeling inside.

"That's my sister," Isaac Dresner lied.

And he took her hand (the smoothness of her skin is somewhere between marble and a clear sky, Isaac thought). Her dress was gasping for air. Isaac noticed that her eyes were circling around things, seeing them from many perspectives. They were like a bicycle riding around a tree. And they stayed like that, the three of them holding

hands, contemplating the end of the world. The soldier left and they remained still:

Bonifaz Vogel, completely upright, his hair white like a seagull's breast and covered with a felt hat (*Alef, bet, gimel, dalet, he, vav, zayin, chet, tet, yod, kaf, lamed, meme, nun, samekh, ayin, pay, tsade, qof, resh, shin, tav*. Amen, he was thinking); Isaac Dresner with his slender little legs and an unbearable weight chained to his right foot, the weight of his best friend Pearlman's head; and Tsilia with her green dress and the impossible cold she felt in her chest (as she beheld Dresden she could finally comprehend the most abstract painting of all). All holding hands, like a family.

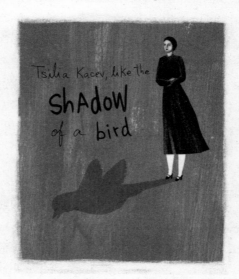

Tsilia Kacev, like the SHADOW of a bird

Part Two

The memoirs of Isaac Dresner
(narrated by himself)

PATERNAL GRANDPARENTS

THE DAY IS HALF DEATH AND HALF LIFE, AS IS EVIDENT IN THE QUANTITIES OF LIGHT AND DARKNESS OF WHICH IT IS COMPOSED

—

That was the day that death got mixed up with life, the day my paternal grandmother died, when a great lunch had been prepared for the feast of Shavuot. My grandmother did not cook because she was pregnant, due to give birth to a son at any moment. A heavy oak table had been placed in front of my grandfather's house (he was a gravedigger). The great oak tree by the entrance was lending its shadow, without asking – as men would do – for anything in return. The mixture of life and death was clear to see:

the dead oak in the form of a table and the living one that was lending its shade.

Most of the guests did not show up, not wanting to eat with the gravedigger (my paternal grandfather), to mix death with life, mix the mouths that bury corpses with the mouths that celebrate life: the people who make a living from agriculture and working the soil. But essentially there is no great difference between a gravedigger and a farm labourer: both place their hope in the earth. Some lay down seed, others corpses, but both hope that life will one day spring from what is being buried.

My grandmother was called Marija and she was from Bratislava, like Rabbi Nachman. Curiously, her profession was the exact opposite of my grandfather's: she was a midwife. The two of them formed a circle, a ring within which all of human drama was enclosed. That afternoon my grandfather pulled out a son from inside her womb. A son born from my dead grandmother, the opposite movement to the one my grandfather was accustomed to: instead of burying the corpse in a tomb, he pulled it into life, unburied a child. He pulled it out from the earth and planted it in the air. That was how my father, David Dresner, came into the world.

THE DEAD HAVE NO NAMES, MY
GRANDFATHER USED TO SAY

—

Then my grandfather went to get his spade, sweated, dug a hole, and united my grandmother with the earth.

My grandfather used to say that the earth upon which we tread is like an ocean: it ripples. An earth wave can be a tree, a dog, a grapevine, a man, a shoe, a baby goat. He lay my grandmother down in her final dwelling place, as if he were putting a child to sleep. He shouted hosanna and affectionately draped her (as he did when they used to lie down together) with dust, the covering that is common to all of us. He marked the location with some stones and there she remained, with no name engraved, just as it should be: the dead have no names, my grandfather used to say.

FROM OUR FLESH WE WILL
MAKE A SINGLE EARTH

—

"I have always wondered who will bury the last man," my grandfather said to my father, "or rather, in this case, who will bury the gravedigger. You will, of course. You are not a gravedigger, but you will bury me in the same earth as your mother, who died as you took your first breath almost three times seven years ago. Her earth will mix with mine, as it did in life, and from our flesh we will make a single earth."

When my grandfather died, my father did as he wished and they were mixed together for ever.

REPEATING THE THINGS YOUR GRANDFATHER USED TO SAY IS LIKE LOOKING AT A PHOTOGRAPH OF HIM

—

My grandfather always thought out loud whenever he was opening up a grave. My father listened to him a great deal while helping him as a boy and frequently repeated the things he used to say. Things like: "A person begins growing vertically, from the darkness of a grave. First a completely empty hole is built, made of pure nothingness. When we dive into that dark place what happens is that, by going downwards, we take flight. Diving into that nothingness is like bending your legs to take a jump. Downwards, before your head collides with the sky."

I never knew my grandfather (I never knew any of my grandparents), but my father told me what he was like: he had an unkempt beard, a scrawny figure, dark eyes, eyebrows that looked like two hands protecting his face from the sun, slightly crooked knees (which I have inherited), and thoughts that were always concerned with

earth. Sometimes my father would grab a sheet of paper and trace out some lines which were, he said, the wrinkles on my grandfather's forehead. At the time I felt sorry for my father and would pray for Adonai to give him the gift of drawing. Perhaps one day he would be able to draw an entire face. At a certain point, I asked him why he repeated my grandfather's sayings so often, and he replied:

"Repeating the things your grandfather used to say is like looking at a photograph of him."

Ultimately, my father didn't need to know how to draw.

MY MATERNAL GRANDPARENTS

THE LIBRARY DREAM

—

My maternal grandmother, Lia Rozenkrantz, had a frequently recurring dream, a dream full of columns and statues. My maternal grandfather, a great kabbalist, believed those dreams took place in the ancient Library of Alexandria. In fact, the dreams were always very disturbing for my grandmother, and she would wake up terrified and in a frenzy. The images were bold, vividly coloured, the kind that do not fade upon waking or as the day progresses. For more than thirty years, my grandfather (whose name was Dovev) slept with a pad of paper and a pen on his bedside table. The moment my grandmother woke up he would pummel her with questions. He tried to get every detail down on paper. He had countless sheets on his desk which were, my grandfather claimed, a map of the library. A map that was redrawn with every dream. He kept modifying the sketches he drew in an attempt to find order in my

grandmother's nightmares. He also tried hypnotism, but without any results.

My grandfather wanted my grandmother to walk through those dreams completely calmly, without getting scared, to pick up papyri and read them out loud. He wanted to recover lost works from the ancient library. For thirty years, he accumulated countless sheets of paper covered in sentences and fragments of sentences, every one of them transcribed from my grandmother's dreams. There were works from Heraclitus, from Andronicus, Pyrrhus, etc., all crossed out and rewritten again and again because my grandmother's dreams kept changing.

Citing the Talmud, my grandfather used to say that a man without a woman is only half a man. But my grandmother would laugh at him and say: a woman without a man is like having one arm and no gloves.

One of the greatest tragedies that occurred on this side of the family involved my grandfather. He used to spend the afternoons with his best friend, Colonel Möller. In fact, it was at the Colonel's house that my mother met my father.

One day, the Colonel's butler murdered my grandfather. My father could never properly explain to me why he did it: he simply told me that the butler was a terrible man, a monster who could not even understand metaphors.

THIS IS WHAT TSILIA THINKS ABOUT
THIS BUSINESS OF MONSTROSITIES:

—

There's this experiment which really frightens me, Tsilia said: the images of every student in a school were super-imposed on top of one another, a composite was made from them all, and the face of the composite was the Greek canon. If even the rabble has a canon, then where does all the monstrosity we are witnessing come from? A long time ago, I heard about a strange experiment involving a piece by Piet Mondrian, one of the square ones, I can't remember the name. They asked some Fine Arts students to make paintings as similar as possible to Mondrian's work. At the end, the results (several dozen coloured rectangles, all imitations of the real thing) were displayed along with the original, without any of them being identified. The visitors were asked to choose the painting they considered the most harmonious. The majority chose the Mondrian, which was full of golden, divinely proportioned rectangles. A very high percentage

chose the original work. This shows that not only is Man composed of divine proportions but also that he recognises them when he sees them, even if he has no visual culture or no culture whatsoever. If it is so easy to recognise that which is harmonious and proportioned, then where does all the outrageous disproportion we are witnessing come from?

MY FATHER DIDN'T MIND MY MOTHER READING THE *ZOHAR*, BUT FAMILY FRIENDS FOUND IT HIGHLY IRREGULAR.

—

My father was a wonderful man but my mother said more intelligent things. Once she told me:

"The Eternal must not be sought in the words of the Torah, that would be absurd. Rather it should be sought in the spaces between the words of the Torah."

"The true Torah has no spaces between the words," I said.

"Well, there you go."

THE PEARLMANS, A FORM OF INCOHERENCE

—

I went to live at the Pearlmans' house because my father went to a labour camp and then, a short while after, my mother died from typhoid fever.

The Pearlman family consisted of five people and two cats. My friend Pearlman was called Ezra, but I always addressed him by his surname. He had two very ugly teenage sisters, aged fourteen and sixteen. The older one was called Fruma, the younger one was Zelda. I used to say that the only pretty one was the middle sister. To be fair, Fruma was even uglier than Zelda and Zelda was even uglier than Fruma. I once saw Fruma bathing, and discovered that, despite being horrific, she had a nice body, perfect even. This seemed incomprehensible, as if her head did not belong to her. It was most curious that her body was not the equivalent of a smile through crooked teeth and sunken eyes that blinked too much. Her body did not have crooked teeth, quite the opposite, its forms exemplified the canon of the ideal of feminine beauty.

And her legs, one next to the other, were two unforgettable things.

Mr Pearlman, my friend Ezra's father, treated me like a son. He owed my father a lot, he used to tell me, but I never found out what those debts were. Whenever I asked him, he would stroke my hair and laugh operatically.

"My father used to say," I said to my friend Pearlman, "that things above are just as they are below. But your sister is very odd."

"What do you mean by that?"

"The lower part isn't like the upper part. It contravenes many laws."

"What do you mean by that?"

Pearlman's sister was the first incoherence I ever saw. I tried to better understand this strange thing of possessing the wrong face. Or was it the wrong body? My curiosity ended up causing some serious problems. My eyes took me places I should not have gone to and I was severely punished for it. But, in short, that was my first incoherence, and we never forget the first time we witness a completely naked incoherence.

The Story of Tsilia Kacev

Tsilia Kacev was a Jew from a well-off, conservative family. She was thirteen years old and at synagogue when she first noticed a red mark on her left hand, a mark which appeared on her hand instead of her underwear, as was happening with friends of her age at the time. She didn't remember having cut herself or anything else that might have explained that blood. She wrapped her hand in cloth and tried to disguise it as best she could. When she got home, she said she had a headache and shut herself in her room. She woke a few hours later and saw in the mirror that she had blood on her forehead. She initially assumed that it was from her hand, which she must have wiped on her head, but she quickly realised there was a wound, a line running parallel to her eyebrows. Her right hand was also bleeding, like the other one. She fell to her knees in horror, which is how her mother found her the next morning. She shouted when she saw her daughter on the floor with blood on her face and hands, but immediately understood

what had happened and the implications it would have among her friends and among the entire Minsk Jewish community. The two of them began to hide the "attacks" (as they called them) to the best of their knowledge and ability. Tsilia let her fringe grow and whenever possible used headscarves, hats, gloves, headaches, or the excuses of ailments, dizzy spells and women's problems to conceal them. When the attacks were at their most violent, she would shut herself away for days. Her father never suspected a thing. He was an austere man who left the education of women in the hands of women. He wore his hair combed back, far back, just like his soul. But when Tsilia turned sixteen her father, an important businessman, decided it was time to marry his daughter off. His whole bearing exuded the shape of his soul: a soul that was combed back as far as it would go.

The man chosen to be his son-in-law was a young, ambitious lawyer, admired above all for his natural elegance and his capacious capability for asking questions. Mother and daughter tried to resist the father's plans, but he proved inflexible. Unable to cope with the pressure anymore, Tsilia fled the house and never went back.

The first few years were hard. After trying to commit suicide by throwing herself into the River Svislach (Tsilia could not swim), she was saved by a peasant who gave her shelter for a few days. He was a good man, more or less honest, and lived mostly from shepherding and his

allotment. Apparently the waters of the River Svislach did him no good at all. After the heroic rescue, the man began to feel feverish and was hounded by a dry cough that killed him in less than two weeks. Tsilia left that house in the charge of a neighbour who got her a job working as a maid in a loft in Vilnius. She lived in that house for two years. Her boss, Stepunin, was a big, burly, bulky man with enormous sideburns that went down to his jawbone and looked as if they wanted to go even further. He spent his time reciting Pushkin (he was an expert) and counting the steps from one room to another or, for example, the house to the station. He could convert any distance into steps or verses from Pushkin. His wife Rosa was stooped over, shut away in a body that resembled a season in Siberia. Stepunin did not take long to notice verses more beautiful than Pushkin's walking around his house. Thus, Tsilia's sexual life was initiated by her boss. Stepunin always came accompanied by one or two sonnets.

The attacks had not returned since she had run away, and Tsilia began to believe she was cured. One day, while Stepunin was lying on top of her – his sideburns gently brushing against her face – she began to consider going back home. At that very moment she had her worst ever attack, which transformed a verse from Pushkin into a scream. Tsilia's face was covered in blood, and Stepunin was screaming. Her panicked hands resembled pouring taps as they enveloped her boss. Awoken by the cries,

Rosa appeared at the door to the maid's room. Seeing this scene, she did what a woman like her is meant to do: she kicked out the maid and forgave her husband.

With the little money she had squirrelled away, Tsilia caught a train to some place or other. Fate led her by the hand to Bohemia and then to Germany where, with the Second World War raging all around her, she hid away in a German painter's house in the city of Dresden. One day she left his house and began walking. She hid until she could no longer bear it, which was quite some time. Until the moment at which Bonifaz Vogel and Isaac Dresner were standing before a soldier, holding hands like father and son, and she appeared next to them.

Some months later they went to Paris, and a few years after that Isaac Dresner and Tsilia were married. He was seven years younger than her, but two centimetres taller, which (in Isaac Dresner's head) made the chronological issue one of minimal importance. Paris was good for Tsilia's career, and she became an exceptional painter, but she was still far from the sea, that heavy, fallen sky, and this made her unhappy. Painting brought in a fair sum of money. They weren't rich, but they had money to spend. Tsilia, Isaac Dresner and Bonifaz Vogel, always as a trio, spent long periods in northern France, frequently holding hands. That sea was not as celestial as Tsilia had imagined, but it was still a sky.

Vogel becomes an improbable person

Bonifaz Vogel was becoming more and more invisible. Improbable, for most people. When he left the bird shop, it was as if he had walked through a trapdoor. He spent hours sitting, not saying a word, and Isaac Dresner had to take him to the bathroom to urinate, although usually he had already done it in his trousers.

Humiliated & Offended

Tsilia would paint several angles of reality in the same image, superimposed in layers of ink, like a build-up of grievances. A person would be depicted with their left side superimposed over their right, their upper part over their lower, as if they were dancing from every possible angle, even the ones that can't be seen, because one person's left side differs from their own left side depending on their state of mind. Tsilia managed to bring together what cubism and expressionism, together, could never do. And she did it using only paint and a little bit of herself. Seeing a person from every possible perspective is similar to the way the Eternal sees us, Isaac would say when he looked at Tsilia's paintings.

More than anything, all these perspectives generated quite a lot of money. Isaac could devote his life to developing a failed business, feeding superstitions:

"I have a bookshop of dead souls," Isaac Dresner would often say. "A Hades built from paper. My bookshop is like Dresden: dead souls."

His small shop was on the second floor of a building on a street in the seventh arrondissement. A sign displayed the name of the bookshop: HUMILIATED & OFFENDED. Another way Isaac lost money was through a small publishing house called Euridice! Euridice! This company's sales bordered on desperate. The ignored books, which Isaac struggled to sell, remained in darkness, on a second floor wizened by humiliation.

Family life

The three of them would often sit still on the sofa holding hands, just like when Dresden had been a heap of dead things. Tears would come to their eyes and, invariably, Isaac and Tsilia would embrace until Vogel had to go to the bathroom.

The Book of Exodus,
by Thomas Mann

The morning blended with the cold, creating a reasonably homogeneous mixture. Isaac Dresner pulled up the collar of his overcoat as he walked with a limp on his right foot (because of Pearlman's head), the wind beating against his thighs and cheeks, his eyes, nose, his entire anatomy. That day was an open jacket, exposed to the cold. He entered a bookshop.

A week ago, a bookseller with whom he was in regular contact had called to say he had two books in his shop which would surely be of interest to Dresner.

Omerovic was a tall, dark man, who was always holding a tasbih. There were not many books in his shop, but most of them were valuable.

Isaac Dresner greeted him and was offered tea.

"No, thank you," Isaac replied.

The bookseller insisted and he ended up accepting.

"It's Ramadan, but hospitality is more important.

Hospitality is one of the few acceptable reasons for breaking the fast."

Omerovic served the tea. Isaac Dresner lifted the cup to his mouth, burning his tongue and hands.

"Hold the base and the rim," Franjo Omerovic suggested. "That way you won't burn yourself."

Isaac Dresner waved his hand. Annoyed, he tried again.

The tea tasted like sage.

"It tastes of sage."

"It's black tea infused with sage."

"What about the books?"

"I'll go and find them."

Omerovic placed the books on top of the counter while he prepared a hookah. He offered it to Isaac, who refused. He passed him the first book, and Isaac read out loud:

"*The Book of Exodus.*"

"It tells the story of two escaped convicts. Basically, it's the story of the biblical exodus dressed up in a new outfit. One of the convicts represents Moses, the other the Jewish people. The latter is even given the suggestive name of Volks. He's a pessimistic character who's always repeating the same thing: The road to freedom will lead us to prison."

Isaac Dresner inspected the book. He scratched his head, without commenting. After a pause to smoke and to take a sip of tea, Omerovic continued:

"This book was written by Thomas Mann."

"That's not what the cover says. The author is—"

"I know what the cover says. Mathias Popa, the man whose name is given as the author—"

"A pseudonym?"

"No, let me finish, Mr Dresner. As I was saying, for his whole life, Mathias Popa was a frustrated author. His poems were systematically rejected by all the publishing houses. He tried two self-published editions that were completely (or almost completely) scorned by readers and critics. The story of these publications began one day when he entered the building of a publishing house in Zurich. In the entrance hall, an argument was raging between an author, his wife and the staff. Popa backed up against the wall, away from the commotion. He spotted a big envelope on the table, and on a whim grabbed it and hid it beneath his overcoat. It was a spontaneous act, one Popa himself was unable to explain. When he got home, he took the envelope from his coat. To his surprise, it was an unpublished manuscript by Thomas Mann. Mathias Popa saw how he could breeze into the literary world. After the success that this book would inevitably bring it was very unlikely his work would continue to be ignored. He would type up the text and submit it to a publisher as his own. What you would expect to happen happened: every publisher rejected the manuscript, invoking their customary excuses. Popa was left dejected. Recognising the

undeniable quality of Thomas Mann's text, he decided to shoulder the costs and publish it himself. That's what he did, and this book you have in your hands, dear Dresner, is proof of that. But Popa's plans backfired. The book was a total fiasco. Barely three hundred copies were sold in the whole of Germany. He didn't give up. He sold his house and invested a great sum in that work. There was much publicity, many promotional tours, translations, etc. He did sell more, though the numbers were insignificant. He received some important reviews, but none were positive, not even slightly. Strangely, one of the most scathing reviews accused the author of copying Herman Hesse's style, which goes to show how ridiculous the whole thing was. After so much investment, the conclusion was obvious: the public continued to ignore him, as they had always done. At this point Popa, who still possessed some assets, had an idea. He would write a book in which he confessed the truth; surely this would be a success. On the one hand, imagine the scandal. On the other, public awareness that *The Book of Exodus* was really by Thomas Mann would make sales of both books rocket. Mathias Popa would finally see his efforts pay off, even if he had to spend the rest of his days in prison. But that hardly bothered him. So, Popa wrote his life story, he wrote about how he stole Thomas Mann's manuscript and published it as his own. He still had some money from the sale of his house and invested what was left. The book wasn't bad.

But you already know what happened: the public ignored it. You have here an exemplary tale."

Omerovic handed the book to Isaac Dresner, whose eyes were gleaming.

"Could I contact the author?"

The bookseller picked up a card and handed it to Isaac.

"Here is Mathias Popa's address. He's an old man, with many manias, but he will certainly appreciate your gesture."

"I think we're going to do business. But tell me, Mr Omerovic, how can I be sure that the story of Thomas Mann's manuscript is true? He could have invented the whole thing in order to sell the books."

"Of course, but the beauty of both works lies in that very uncertainty."

As he missed the lock with his key

The sky was loaded with incontinent-looking clouds, but eventually it cleared and they went off to rain upon other great European capitals. Isaac stopped at a brasserie to drink a glass of wine and eat a plate of cheese and bread. He stretched out his legs as he observed the scene around him, crowded with closed umbrellas. He reached for his bag and began to reread Mathias Popa's second book. He sat there engrossed, a little touched by the cold, like a winter pear, reading that work that had been devastated by obscurity. He walked home, limping on his right foot, the book in his hand. He did not stop reading even as he went up the stairs. He kept the book open while talking to the porter, continued to read as he missed the lock with his key and as he opened the door. Isaac Dresner hugged Tsilia, put down his bag and took a seat. She suggested he sit next to Bonifaz Vogel. Tsilia was painting him and wanted to add Isaac's image to that of Bonifaz. You can't paint one without the other, she said.

Bonifaz Vogel was completely naked, his mouth open, sitting on the chair where he usually spent a good part of the day staring at the window or listening to the radio. Whenever he heard news of war he flinched and his eyes grew wet with tears. Vogel's flesh, too mature, almost falling from the tree, wrinkled in the cold. The heating was turned on, but Vogel insisted on opening one of the windows, and the cold came in through it, enveloping him. Isaac Dresner kissed him on the forehead and pulled up a chair to sit next to him. Bonifaz looked at him with a weak smile, but his face was still sad and his skin still whitened by the passing of time. It was only then that Isaac noticed Tsilia had bandages on her hands.

"Again?" he said. "I hadn't noticed."

"It's been more than a year since it last happened. It's just on my hands."

Outside, some sycamore trees, having bid farewell to their driest leaves, were almost touching the windowpanes. Everything else was grey, a mixture of black and white. Isaac got up and reached for his bag. Tsilia squeezed more colours out onto the pallet, mixed turpentine with linseed oil, and began to paint.

"May I read?" Isaac asked as he opened his bag.

Euridice! Euridice!

That night, Isaac Dresner lay down holding one of Mathias Popa's two books and fell asleep in the same position three hours later. He finished the book the next morning during breakfast.

When Mathias Popa answered the telephone, his sleep has still not woken up.

"Yes?"

"My name is Isaac Dresner. I'm an editor and I would very much like to speak with you about the books you published."

"I've waited my whole life for a telephone call like this. What did you say your name was?"

"Isaac Dresner."

"From which publisher?"

"Euridice! Euridice!"

"I've never heard of it, but I like the name. I hope it's small enough to cope with my lack of success."

"It's tiny. So small that it can only grow."

"Listen, Mr Isaac Dresner: I've had enough disappointments to last a lifetime. I have a pension and some time to myself in the company of one or two bottles of wine per night. I no longer wish for much more than that."

"Can we meet to talk more about your disillusion?"

"Come and meet me here. If you have my telephone number, then doubtless you have my address. I don't know what unwitting person gave them to you. If by some chance I am not at home, you will find me at the end of the street, in a pizzeria called Tintoretto. Or next door, in Brasserie Vivat."

"What time?"

"Any time. I'm always in one of those three places, it's my way of being three and one, only rather than being all three at once, I am more methodical than God: I'm never in more than one place at a time. It's not so practical for having meetings, but it allows me to be more concentrated. God spreads Himself thin."

"Any time, you say?"

"Any time."

"I'll come tomorrow, as soon as I wake up."

"Do that. I'll be waiting for you. That is my vocation."

The Métro was full

The Métro was full, so Isaac Dresner waited for the next one, which arrived almost empty. Isaac got on and picked up an abandoned newspaper. He read it during the journey, and when he got off he left it in the same place he had found it. He buttoned up his overcoat, because there was a great gust of air blowing into the station, and headed for the exit. Limping on his right foot, he walked two blocks – despite the cold, the rain was elsewhere – and rang the bell of an old, sturdy building (built to withstand the elements).

"Isaac Dresner," he replied when his name was asked.

He went up the stairs, sometimes two at a time, and found himself standing before a dark wooden door. He waited a few seconds, without knowing whether or not he should knock. He waited a few more seconds before raising his hand to knock again. Before he was able to, the door opened and a man in a dressing gown appeared in front of him. He had an ancient face, the face of a man who has

lived through a great deal, with eyebrows whitened by sadness, a dirty beard and a wrinkled forehead. Isaac Dresner introduced himself again and Mathias Popa opened the door wider without smiling. His solemn air was his way of showing hospitality. He gestured dramatically for Isaac Dresner to enter, accompanied by something resembling a bow. Isaac walked wearily into a quantity of mess contained only by the modest size of the apartment. A bedroom, a living room and kitchen, a bathroom. The rest was all books, two guitars, a piano, two violins and some woodwind instruments, notably four saxophones: two tenors, one alto and a baritone. One of the walls was completely covered in damp and gave off a smell of mould that filled the apartment far more effectively than the furniture did.

Isaac Dresner introduced himself (again) and Mathias Popa extended his hand (which was rough, like an insult). He invited him to sit and offered him coffee or brandy. Isaac asked for both, mixed together.

After some chitchat, Popa began to talk about one of his books:

"My first prose work told the story of a band that existed only for God's ears. A blind man played a simple accordion melody on a street in Tirana. Meanwhile, in perfect harmony, a Chinese woman played the piano in a Moscow lounge. A bluesman in New York played the ground rhythm on the double bass. In Corumbá, Brazil, a soloist played a second harmony on the trumpet. A domestic

servant in Vienna hummed an aria, perfectly complementing this music. And so on, all over the world. The music kept changing, the melody kept changing, becoming the greatest, most complex, most beautiful composition ever played. They had never met, knew nothing of each other's existence and they would never have imagined that what they were playing formed part of a far greater whole. I described thousands of people over hundreds of pages. I wrote a little about their lives, where they lived, and then I described their contribution to the musical group in great detail. The entire story took place over seven minutes, which was the duration of that piece of music. In the narrative, only God knew the whole melody, but in real life, I heard it. I made all those people play, and in my head I heard the whole composition in all its complex orchestration. I'm a musician, you know, I always have been. Even before I could play an instrument. All of my books are pieces of music, only with letters. Essentially, they are the same thing. Do you suppose I am incapable of hearing the thousands of musicians I created, all of them playing at the same time? You're wrong. I hear all of it. All of it."

"What happened to that book?"

"I think Thomas Mann stole it from me and used it to write *Doctor Faustus*. I'm joking. One day, after receiving all the rejection letters in the world, I threw it onto the fire. I never heard such a hot piece as that one."

"And you never had a career as a musician?"

"I did. I played violin with Ray Brown and sax with Chet Baker, to give you a few names to entertain yourself with, but my life was elsewhere. What I really wanted was to be a poet. I'd play drunk and even then I was better than all the other virtuosos. But I lacked the dedication. It didn't interest me. You don't know, Mr Dresner, what it is to have a gift of this size. When a glass shatters, I know what note it strikes. But I always lacked musical ambition. I know music back to front, and perhaps for that reason it exercises no fascination over me. To be frank, I have always considered my talent to be a curse. It wasn't something I wanted for myself, but everything pushed me towards it. I could have been the greatest musician in the known universe, but my passion lay elsewhere."

"I think your books are very good."

"They are. Even though one of them was stolen."

"Was it really?"

"Of course. Do you think I would lie?"

"I think you are perfectly capable of it."

"You don't know what you're saying. Lies do not exist in literature, in fiction. What's more, truth does not exist in real life. If you understand this fully then you will understand many other things as well. Would you like some more brandy?"

"Yes please. What became of your poetry?"

"One day, while reading the newspaper, I lost all my poetic feeling. I felt empty, completely hollow. One reads

the newspaper and ends up losing poetry itself. It wasn't because of being rejected by the editors and all that, but because of society. Wars and the like (at the time the War of the Sands, between Morocco and Algeria, had just begun and by then I'd had it with wars). I grabbed hold of all my work, more than four thousand poems, and buried it in an abandoned lot near my house. I was living in Cairo at the time. After I buried it, some little plants grew in the exact spot where I'd dug the hole. I was happy because nothing had grown around it, only where I'd buried the poems. I'm not sure if it was because I'd stirred up the soil or if it was Nature showing its inclination towards poetry, rejected poetry in particular. In the end, it's manure that makes things grow, isn't it? Every day I'd walk past that spot and watch the plants growing. I enjoyed it, and it became a ritual for me. I'd take some food and a folding canvas chair and sit down to watch them grow. A year later a fence was put up and a house was built. Look what can be made from a few lines of poetry. Every day I walked past it, and I ended up missing rehearsals and concerts. Once the house was ready, a lovely family came to live there, and they became my new obsession. I began to live in front of the house: I'd sit on the pavement and play the tenor sax. I put my hat upside down on the ground and earned a few coins.

"It didn't amount to much. One day, the youngest girl (the family that moved into the house consisted of four

people: a couple and two daughters) brought me a shish kebab. But she didn't say anything to me. She placed it next to the hat and entered the house, as she always did. A week later, and for no apparent reason, I grew tired of all that. Samuel Gomez, of the Sam Gomez Trio, offered me a good opportunity to get away from there, from outside that house that had grown from my poems. I knew him well from when we played together at a Coltrane tribute concert, with all the big jazz stars. When he saw me holding my sax on a street in Cairo, standing in front of the house I had just that minute stopped being obsessed with, he suggested I play with his brother, also a musician. A more or less competent drummer. I accepted, and played with him in the best hotels in Egypt, but I ended up getting involved with a hooker in Alexandria who – I won't tell you the whole story, but that's why I have this scar above my eye – wanted to kill me. I wasn't scared of her, but I didn't like the company kept one bit. So I decided to catch a boat to Europe. I paid my way by playing in one of the ship's bars. The audience consisted mostly of drunk Scandinavians. I never saw so many in one place, not even in Sweden a few years later. I worked in a pizzeria in Italy (hence my taste for pizzas, it's like a disease), in Trieste. That summer I went to Switzerland for a temporary job and ended up staying there. I started playing in bars again. Life was good. I bought a house on the outskirts of Zurich, with a little plot, and that was when I decided to

write *The Seven Minute Band*. I think the letters of rejection I received outnumbered the amount of copies I sent out. You know the outcome already: it ended up in the fire. Still, I wrote another novel, which told the story of a man who was never born. His mother died during pregnancy.

"Her son remained alive, always inside the womb. It was a parable for our limitations, our fear of the unknown, of risks and such things. You know, Mr Dresner, we all live well below our potential threshold. We live in the garage of a palace, or a cave, that's what we do, like a foetus that never leaves the uterus. This character was just one more person who didn't want to leave his world and go out into the light. It was a Kafkaesque narrative. The publishers, as you've doubtless guessed, rejected it with all their powers of rejection. But as I was carrying the original of *The Man Who Was Never Born* – which was what the novella was called – for a Zurich publisher's consideration, I found myself in the midst of a confusion between an author and some of the staff at the publishing house. There was an envelope on the desk in the entrance hall, upon which I could clearly make out Thomas Mann's name. I found this strange, because he'd been dead for a number of years, but the unpublished manuscript had probably been sent by someone to whom he had entrusted it. At least, that's what I think. What I did was spontaneous. It wasn't a premeditated act: I'm going to steal a Thomas Mann original, edit it as if it were my own and become a great *homme de*

lettres. It wasn't that at all, it was merely a foolish impulse. I had never stolen anything in my life. Well, I had, but only the same things everyone steals: a ballpoint pen from an office, a colleague's rubber. Stealing office materials does not make you a thief, am I right? But I had the impulse, so I hid the envelope beneath my jacket and went home. I was so nervous I couldn't think. The following week I had an idea which was basically the logical conclusion of that theft: to leave the country and publish a Nobel laureate's work as my own. That was what I did, and yet I'm sure you have already guessed the dismal outcome: I received the customary letters of rejection. One after another. I think I'm acquainted with all the publishing houses in the world."

"You didn't know mine."

"I'm exaggerating when I say all the publishing houses in the world. Essentially, it's the same as saying God knows everything. Or that He's completely good. What about your publishing house?"

"What about it?"

"Does it publish?"

"It does. Have you got something for me?"

"It can be arranged," Mathias Popa said. "It was a pleasure to wait half a century for you."

Isaac finished his wine in one gulp and returned home, leaving Popa asleep on the sofa.

It's very dark inside a bird

Isaac Dresner slept like a stone that has been tossed into the sea, waking up energised and with an urge to eat several croissants. He ate two.

"Birds eat seeds," Bonifaz Vogel said when he entered the kitchen. "I don't understand why trees don't grow inside them."

"I think plants need light to grow, and it's very dark inside a bird. It's even darker inside a man."

"I see lights when I close my eyes. If it's dark there, then where do those lights come from? Everything is lit up when I dream. I wouldn't see anything if it wasn't. Where does that light come from, Isaac, where does it come from?"

Vogel had a urine stain on his trousers. He always came back from the bathroom like that. He was incapable of shaking patiently or efficiently. Isaac hoisted him up with his nicotine-stained fingers and forced him to go back to the bathroom.

"I'm sad because of the countess."

"If you're not happy with the way things are going, Mr Vogel," Isaac said, "you need only do one simple thing: put your feet together, concentrate and take a little jump in the air. When your feet touch the floor again, the reality of the floor, when they leave the celestial moment of the jump, I repeat, when they touch the ground, it will cause a slight tremor that will alter the direction of the Universe. If it's going in one direction, a direction that is clearly causing you displeasure, you need only jump to change the direction. But because the tremor is very slight, the effects cannot be seen straight away, and yet if you could see into the future, you would see just how different the future in which you didn't jump turned out. Life is made of such hops."

"I've jumped, Isaac, but nothing is happening."

"You must be patient, Mr Vogel, patient. Shake properly so you don't wet your trousers. That's it."

"I'm not young anymore, Isaac, in fact some parts of my body are quite old. I love the countess very much."

"It's quite clear that you understand nothing of fate and such like. Have you ever noticed that, when you call for a cat (remember Luftwaffe, Mr Vogel?), it rarely runs towards you in a straight line? Rather, it makes a parabola, a curve. Cats know very well how to achieve what they desire, they are precise, efficient predators, and they do so in an arched formation, moving in curves. Our fate is

the same, we create curves and parabolas so that it can be carried out with perfection. The shortest distance between two points is the circle. What's needed is patience (our most spherical mood)."

"I'm sad because of the countess."

Love letters, swallows

"Mr Vogel is sad," Isaac Dresner told Tsilia. "He says he loves the countess, that lady he sees when he goes shopping, the one who's always very made up, with an old-fashioned body. He stands there watching her in the tinned and fresh goods sections. He follows her, and I think she likes it. They've never exchanged a word, which is a relief. Neither one seems much disposed to talking."

"He is sad, I've noticed it too," Tsilia said. "Talk to him, counsel him, tell him to talk to her. Tell him to talk about birds and Dresden (which is sad but beautiful)."

"I've tried, but he just wells up and sobs. He says he feels cold, but I reckon he's confusing shivers brought on by nerves, sadness and melancholy with a lack of heat. The girl at the till says the lady is called Malgorzata Zajac and that she's an aristocrat of Polish origin."

"You should write to her in Bonifaz's name. He'll like that."

"Write her what?"
"Love letters."

Epistles to the countess

Dearest Countess,

It is with a certain boldness that I write this letter to you, but my
bones are withering with time. Not with the time that passes us
by, but with the time that sinks deep into the skeleton and the
medulla and brings us the particular rheumatism that is the
fact of life passing us by. It is not time that ages us, but time
ill spent. And the time I spend without you, dear Countess,
withers my bones. But what can be done if, when I see you in
the supermarket with your bag full of bread, contemplating the
tinned goods, I find myself lacking the words of which I am
made? Did you know, beloved Countess, that Man is made of
twenty-two letters? An alphabet that the Eternal can link together
into what we are. To Him, we are just letters and numbers. And
he dictates a book for everything, be it a stone, a man or a tin of
beans. This combination of letters makes us into creatures which
can be distinguished from stones because we know what interest
rates are. To tell the truth, I believe the stones we see around us

are not the minerals the geologists believe them to be, but are in fact the remains of human hearts, of those humans who wake up in the morning to go to work and who do not know how to love with any aptitude. That is how stones are born, from the remains of hearts. I saw war happening right by my bird shop, and I know that it turns everything to stone. When I looked out at Dresden, it was a heap of stones. Where did the stones that the war produced come from? Evidently, they came from the bosoms of men. Those dead stones were the hearts of the men of war. The stones and the dust that could be seen all around.

But when a man can love the way I do, plants come to life in the fields and the little birds sing inside us (not outside, as those who purchase canaries believe). The chirping of a songbird can be heard inside us. Ill-informed people believe that it is the canary making them, but it is our souls trembling at the sound of a bird's song. That is how the chirpings are made. From trembling souls. Thus, Countess, my soul is a small earthquake when it beholds you holding your bread bag, inspecting the tinned goods. Your entire figure, when I behold it, is a bird's song.

With this letter, dearest Countess, apple of my eye, I want only to show you how much someone can be loved. Love is not infinite, as the poets claim. Nor is mine infinite, far less that of other people. What is infinite is the object of our finite love. For me, it is you, Countess, who are infinite. I am merely someone capable of contemplating the horizon that is you, Madame.

With love, Bonifaz Vogel

My beloved Countess,

I would like to take you to lie down with me under the African
sun, perhaps spend a night in the Polana Hotel, hold you by
your curves and dance until the orchestra can play no longer.
The chairs rest upon the tables, and with their last breath
the musicians play one more, terrible version of "Stardust".
"*Sometimes I wonder why I spend the lonely night dreaming of
a song.*" And I would hold you by the soul and pull you through
the streets of my heart, and our sighs would be as one and we
would be a single dancer. "*The nightingale tells his fairytale of
paradise where roses grew.*" And I would let your lips be two
red words glued to my mouth, the upper word and the lower
word, that is, the two words which make up the world. "*And the
dreams come true and each kiss an inspiration, but that was
long ago.*" And we would go to our room, which would be on the
sand on the beach, full of night, hugging a bottle of champagne
I would have stolen from the bar. The following day, if we were
able to wake up, we would eat prawn curry while looking at
the sea and out into the Indian Ocean of your eyes. Do you like
curry? I am certain you do, for I have seen you buy a packet at
the supermarket. "*Now my consolation is in the stardust of a
song. Beside a garden wall when stars are bright you are in my
arms.*" It was a packet of spices, wasn't it? I want to believe it
was. From the colour, it could have been saffron. Dear Countess,
at times love creates a new spectre from the rarefaction of light,
and what is yellow to some can be a rainbow to someone who

is in love, head over heels in love. The packet, then, could well be something else, but the love is still the same. Or perhaps it's different. But if it is different, it is because it is greater.

Your own, Bonifaz Vogel

Most beloved Countess,

I know that the world is very tiny indeed. I do not say this because I live in a four-room apartment divided between three people. I say it because the world is far too small for a great love such as ours. And yet the world is very big, since, however much I extend my arms and my soul towards it, I cannot reach it. You see the contradiction. On the one hand, I do not fit in the world, on the other, I cannot manage to touch someone who has so often been only centimetres away from me, inspecting the tinned goods. My voice falters every time I see you. Recently, however, I have not seen you. Have you changed supermarket? Returning to the topic of the spaces occupied by things, I could write an extensive essay, pages and pages long, with countless letters, letters that could be read for all eternity. Distance and the like are complex matters. If the Eternal ever unwraps this secret, many things will change. One day we will be able to understand how a finite thing can contain infinite things and how it is, for example, that a heart as dedicated as mine, so small, so full of

arteries and suffering, can contain something as long as love. Something as spacious as passion. Know, dearest Countess, that I believe in the Eternal the way a child draws a picture. I think that the next picture will be better, and I think the same about Him: His next Universe will be better. He is growing too: it is no coincidence that everything is always expanding, no coincidence that we are treated as if we were toys.

In this way, the Eternal, having all the time in the world, will be able to recreate everything that does and does not exist. And we too, my beloved one, will have an eternity of new sketches, better every time, to discover inside each other, like those Russian dolls. Myself inside the countess and the countess inside of me, ad infinitum.

Ah, if only science could see you the way I see you, it would not spend its time gazing at stars through a telescope! The countess is the best explanation for the Universe. One need only gaze upon your profile to know everything, to discover how stars are born and how our hearts became planets circling around unhappiness.

Eternally yours, Bonifaz Vogel

I am writing a new book

The sign read

"HUMILIATED & INSULTED"

Mathias Popa climbed the narrow stairs. The book-shop was very small, a cube of unhappiness. In the middle was an island upon which the most recently published books were displayed. The shelves surrounding it held other, older books. The shelves were made from an austere wood and the books had covers that were like monks' cells, Carthusian monks in particular, so simple were they all. On top of a desk that served as a counter was a reproduction of a Bruegel painting, 'The Triumph of Death', with the legend: "Dresden, 1945". Mathias Popa moved through the tight space until he was standing next to Isaac Dresner.

"I'm writing a new book."

"What's it about?" Isaac Dresner asked.

"Who knows. About love or hate, the human condition, that sort of thing. What is any book about?"

"I was hoping you might be more specific."

"Have you heard of the Varga family?"

"Of course. They lived in Dresden, like I did," Isaac Dresner said."

"Then we all lived there."

"You used to live in Dresden? Before the war?"

"Before and after. I watched it all collapse, as the sky was drained by so many tonnes of bombs. People were flying, like in a Chagall painting. It was all very artistic, if a little macabre. They were difficult times. Hitler caused the Jews a spot of bother. You escaped, then?"

"As you can see. I'm amazed you've lived in the same city as I did."

"Why? There were lots of other people there. It's normal for them to eventually meet. Anyway, look, it's Dresden I'm writing about. About the Vargas and about Kokoschka."

"The painter."

"Yes, but he is not of any great importance to the story. He's not even one of my favourites. From that period, I prefer Schiele and even the other one, Klimt. What matters is the doll made by Hermine Moos, a doll commissioned by Kokoschka. It changed the Universe, but above all, it changed my life. I'll tell you more next week. Come and have lunch with me at the pizzeria."

Isaac Dresner limped through his past

Isaac Dresner and Mathias Popa began meeting for lunch every week. On some occasions, Isaac limped through his past while Popa listened to him. On other occasions it was Popa who struggled against his memories while Isaac listened.

"The book I am writing is very important to me. It is my last," Popa said.

"How so?"

"I am dying, and it is very important that this story be written down. Enmerkar, the Sumerian, was condemned to drink stagnant water in the Mesopotamian hell for not putting his feats down on paper. There is no greater sin than that. And the punishment is dire. Imagine that Mesopotamian eternity, drinking only water. For me, any water, stagnant or otherwise, is bad enough. Anyway, I have decided that you, my friend, will appear in this book. You won't understand yet, but when you are put into writing, in a far more grandiose form than the way you are now,

you'll see that I am right. You'll be stunned by yourself, your jaw will drop with surprise."

"I'm going to be one of your characters?"

"On the contrary, Mr Dresner, you are one of my character's characters. My creation is far more perfect than you are, he's taller even. You must know that I was very impressed by your story about the cave."

"It wasn't a cave, it was a cellar. My father built it before the war started."

"A cellar, of course. I shouldn't have made that mistake. It is the place where wine is kept. But essentially, it's all the same: a cave, a cellar, a dungeon, the underworld, Hell, Egypt, the Treasury, it's all the same archetype. I was always too scared to delve into the darkness. Suffering has somewhat passed me by. There's no doubt that I dislike wars or women who don't have wide hips, but apart from that not much affects me. I prefer wine and pizza to suffering. That must be why I can't move on from all this flotsam. Just like you, Mr Dresner: you do not do justice to that hole in which you were laid up and have become little more than a tired, depressed voice which has already forgotten that youth spent counting the letters in the Torah, reading the Zohar and the Sefer HaOr and creating golems underneath your bed. I'm going to free you from this birdcage with the help of a book about a doll. You are no more than a shadow in Plato's cave. My character is the true you. If you ever emerge from the cellar you live in,

you will see that you have been merely a feeble imitation of yourself."

"But you hardly know me."

"We've met a few times, and that's enough for me. I am able to see people the way they really are and not just how they appear or how they dress in this world. I understand a person simply by looking at them."

"Right. I wish very much to read this book of yours. Did you say you were dying?"

"I am, I am. We all are, but in my case the doctors have actually given me a deadline, you understand? They say it's something in the brain and that they can't operate. I wouldn't want strangers fiddling around in my brain anyway. Who knows what ideas they'd find in there."

"I'm very sorry."

"Don't be. Look on the positive side. There's always a positive side. Hitler's moustache looked very funny on Chaplin. And Chaplin's moustache was an abomination on Hitler. The exact same thing, in a different context, determines our joy or despair. Duchamp had the right idea with his urinal: it's the context that creates the art and the drama and the misfortune and the joy. Put my death in a favourable context. You'll see that it is not harmful. Put Hitler's moustache on Chaplin's face. Listen: in two months' time the book will be ready. The doctors have given me more time than that, but I don't want to risk it. Doctors are like meteorologists: their forecasts are never quite accurate.

KOKOSCHKA'S DOLL

~ MATHIAS POPA ~

EURÍDICE! EURÍDICE!

MATHIAS POPA

was born in Dresden.
He is an exceptional musician who has played
with some of the greatest names in jazz.
This is his third book. He is the author of
The Book of Exodus and *A Thief's Confession*.
He lives in Paris, in constant despair.
The only company he keeps is
pizza and wine.

Kokoschka's Doll

THE STORY OF
ANASZTÁZIA VARGA

CHAPTER 1

Anasztázia Varga, Adele's grandmother, was the daughter of a Hungarian man called Zsigmond Varga, an eccentric millionaire (or perhaps the other way around) who was father to more than fifty children, only eight of them legitimate. Anasztázia, the youngest, belonged to the latter category. She had always been a kind sort with a lovely smile and that tragic characteristic called altruism. She was incapable of seeing destitution without being greatly moved. She had only to read a book in which poverty was depicted or walk past a beggar outside a church and the tears would run down her red cheeks. Anasztázia Varga had a round face with prominent cheekbones, in the Magyar style, a slender nose, almost like the blade of a kitchen knife, even slenderer lips and gleaming white teeth, all side by side, unhurried, uncluttered, unfrenzied, forming a jawline so perfect it looked artificial. Her hair was soft, and dark like even the most luminous human soul. There are not many great stories to be told about

her life other than the one that would mark her destiny in such a pronounced way that it brought her a small kernel of madness, along with an unwanted pregnancy.

It took place in the year 1946, a troubled time. The Second World War had finished – and finished off Dresden – and Varga's family had been demolished, with few survivors. All of the family's men had died in the war, some heroically, others with great cowardice, others accidentally. The endless bombardments (because those explosions were far more profound than the buildings' foundations attest) to which the city was subjected, killing many thousands of civilians, were survived only by Anasztázia, Zsigmond Varga, and four grandchildren who would die of scarlet fever a few months after the war ended. While medical resources were scarce, death's resources were, as ever, all too numerous: sometimes we escape from a bear only to encounter a Nazi; other times we escape from a lion only to encounter a devastating microbe, lodging in our organs. We escape from what is outside, yet we run away with the enemy inside our bodies. Sometimes we survive a holocaust only to be hampered by a beta haemolytic streptococcus group A.

CHAPTER 1

Anasztázia was walking along one of the banks of the Elbe with a servant one day when she heard a low howling which almost blended in with the sound of the river. The servant began to walk faster, clinging onto Anasztázia's arm; she, however, began to slow down in an attempt to discover where this dark lament was coming from. It was just past two in the afternoon, but the sight was a nocturnal one. A gigantic black man was lying next to a low wall. Anasztázia did not hesitate and ordered the servant to call Dr Braun, the family doctor. In the meantime, not knowing what to do, she took off her jacket to cover that giant who was trembling with fever and whose eyes were rolled back, displaying all the white they possessed. Then Anasztázia sang him some songs, often going out of tune.

CHAPTER 2

When Braun arrived with a nurse and the servant, he quickly realised they would need more people to carry the man.

"He's very sick," Braun said. "He's likely to succumb. It's pneumonia. We'll take him to my house, but I doubt it will be possible to do anything. In any case, we need more people."

He turned to the nurse and gave him some money:

"Find two men to help us. They must be able to lift heavy weights."

The nurse appeared with a red-haired, broad-shouldered man wearing a sailor's cap which felt completely out of place in Dresden. The other man was a beggar who didn't look as if he'd be much help: he was old and hunched over, with a dirty beard. In the end he proved himself to be an energetic man, certainly far younger than the train wreck of his physical appearance suggested. Their speech was coarse, but Anasztázia was more or less used to it. She had

seen many things by now. The doctor kept scolding them, but to no avail.

The enormous black man was taken to the doctor's house, where he stayed in an outhouse kept for emergencies such as this one. The building was covered in ivy and situated about seven or eight metres away from the main house. Despite how small it was the room was always cold, perhaps owing to the way it had been built and how far it was from the house. The age of the shutters and windows did not help.

The sick man coughed and shivered, but anyone looking at that monumental body would not doubt its ability to overcome any illness. Anasztázia continued paying him daily visits, spending hours at his bedside, often holding his hand and placing damp cloths on his forehead when his fever was high. She sang to him, not always in tune, and prayed and read him books, and gradually the man began to recover. The cough eased up, the fever began to abate and Dr Braun kept his discretion. For Zsigmond Varga, having a young lady like Anasztázia involved in such Christian activities was not in good taste. Because of this, Anasztázia's father was not aware of what was happening.

One day Eduwa, which was what the man was called, got up. Dr Braun encountered him in the backyard, cutting logs with an axe. His chest was bare, despite the sub-zero temperatures, and his body was exuding good

health and droplets of sweat. With each blow of the axe,
Eduwa let out a grunt capable of stopping the wind in its
tracks. Dr Braun reprimanded him; Eduwa needed rest.
He did not seem to understand, for he continued to cut
logs with all of his tremendous physique. Braun realised
that he had fully recovered, but that there was no place for
him in his house. Anasztázia volunteered to find him a
job that would help him live with dignity. Because she was
more or less in charge of the domestic management of
the Varga household, there was little difficulty in getting
Eduwa work as a gardener at her father's property.

CHAPTER 3

The Varga property included a nice house by the road, surrounded by a fairly big plot of land – bearing in mind that this was in the city centre – and full of fruit and ornamental trees, aromatic herbs and stone walls. The house, which had seven floors, had been designed by the Hungarian architect Imre Lakatos. It was a perfect copy of another house that the millionaire had commissioned in Budapest. Zsigmond Varga's legitimate children had lived in those two houses, first in Budapest, then in Dresden, before the war broke out. Anasztázia was born in Dresden and never saw the Hungarian version of the house. Nor had she ever seen her older sister Lujza, who had been disowned and expelled from the home because of a forbidden love affair.

Eduwa was happy living there. Every day he would pick flowers and leave them by Anasztázia's bedroom. She used him as her confidant, while he remained silent, barely listening to what she was saying. Anasztázia would

tell him about her fears, her romances, her clothes, difficult decisions she had to make, while Eduwa listened quietly, with his profound body, his immeasurable hands and his distant silence. She would rest her head on the giant's shoulders and his eyes would become moist. When she sighed, he would sniff and jiggle his legs nervously. She would stroke his face, which was prematurely aged by misfortune (it ages people far quicker than time does), and he would be even more moved and feel his skin grow warm, as if the sun were shining on him.

Eduwa lived there happily for a few months until someone told Zsigmond Varga that his daughter Anasztázia was having an intimate relationship with the gardener. It was a father–daughter relationship, and vice versa; she talked to him, gave him food, smiled at him, little more than that. Eduwa shared the food he received from Anasztázia with the other people who worked at the property. Evidently one of these people, who had so often eaten Eduwa's bread, left a note for Zsigmond Varga which denounced Anasztázia's behaviour. Implacable as ever, the old man grabbed a gun and ran over to the gardener's cabin. Anasztázia did so too, a fact which saved Eduwa's life, because she would not let go of her father, causing the gun to fire into the sky, missing Eduwa but hitting the unintended target of fate. The gardener escaped and ran to the doctor's house. The following day, Dr Braun sent Anasztázia a message: Eduwa was at his house. Anasztázia

ran to the doctor's house, her nerves a wreck, and after analysing the situation she decided she would rent a small apartment with the allowance she received from her father. The allowance wasn't all that great, but Eduwa was able to live in a small room in a public building. Whenever she could, Anasztázia took him food and records (she had given him a gramophone). Sometimes she would dance with him, no matter how embarrassed or rigid he became. Eduwa moved like a wooden spoon stirring soup. Anasztázia would grab him by the waist (which was chest height to her) and sway with him, as far as it was possible for her to move that mountain of unhappiness. When he became embarrassed, Eduwa would smile, looking downwards in delight. One day in Autumn 1948, Anasztázia brought her protégé a roast chicken in a wicker basket. When she arrived, accompanied by the smell of the freshly cooked food, she found Eduwa curled up in a corner, having most likely fallen out of bed, covered in rags and shivering. He was feverish, his eyes bloodshot, his whole body rocking back and forth like a fan, with a chesty cough that could have torn a tree out by its roots. This time, when Dr Braun came to his bedside, it was only to delay the inevitable. Eduwa was going to die. But because he was so happy to see Anasztázia's face close to him, he uttered a sentence that would seal the girl's fate: he told her that he had to pay for all the happiness he had experienced and that he owed an offering to Oshun. He grabbed her arm and made

her promise she would do it. When Anasztázia asked him where she should make this offering, he replied, with his customary simplicity: in Africa. Nigeria.

CHAPTER 5

Anyone else would have dismissed that insane plea, stroked the dying hand and said goodbye with tears and a kiss on the forehead, but Anasztázia carried out Eduwa's request. She buried her friend, and the following day she spoke to her father: she wanted to travel, get to know the world. She needed money. Zsigmond Varga did not even look up from his desk. He simply opened a drawer and handed her an enormous bundle of notes.

"That should do," he said. "Travelling does wonders for the spirits and is preferable to you getting lost in your sentimentality. What those layabouts who you're always trying to help really need is a good lashing. When they do have money, they just drink it away. They don't work, they don't use the money to make more money. A few lashes, and they'd be capable of anything. If you want to help them, then you must whip them like animals. A donkey with no yoke is but a wild ass. Where will you go first: Paris or London?"

"Paris," Anasztázia said, without mentioning that Paris was simply her point of departure for Africa.

Her father did not respond. He had gone back to being hunched over his enigmatic papers, covered in numbers and graphs.

Anasztázia arrived in Paris the following month with a suitcase almost as big as she was. She did not go directly to Nigeria because she wanted to use the journey to get to know the world. That included Paris and some other European countries, but also all of North Africa.

CHAPTER 8

The Federal Republic of Germany was founded in September 1949, while Anasztázia was travelling. On the same day, Zsigmond Varga let out his last sigh. He ate a small meal, one incapable of absorbing such a capacious wine. He decided to take a short walk to aid his digestion and headed towards the annexe where he kept his colossal collection of butterflies, both dead and alive. One of the gardeners found the dying man on the floor, bent double, with some butterflies (*Papilio demodocus*) beating their wings above him. The gardener crouched to listen to what he was saying, but all he could make out was the word "scales". Once Varga had expired, he closed his eyelids and ran off to alert the other employees. Varga remained lying on the floor with his mouth open. Dr Braun ran to Zsigmond Varga's house the moment he heard what had happened and asked the servants to leave. Some were crying on the outside, others were smiling on the inside, others were doing both. Braun chased them out of the

annexe with harsh words and grave expressions, until the only person left was a policeman who, once the doctor had arrived, stayed at a respectful distance from the body. Braun leaned over the millionaire's corpse and seemed to observe a butterfly coming out of his mouth, as if it were the old man's soul. The doctor sat still, watching it beat its wings in flight towards the rays of sun that shone through the clouds and through the glass of the annexe's huge greenhouse. The doctor's eyes followed the butterfly until it had flown out of sight, blended in with the afternoon light that was entering the building. Braun rubbed his eyes to regain his vision which had been weakened by the bright sunlight and looked down, closing Varga's gaping mouth (it looked like a big "O", like the open mouth of a man without a soul). He noted down the time of death and made efforts to inform his two daughters, Anasztázia and Lujza, the only people who might want to know about Zsigmond Varga's death. He had hoped to deliver the news in a more personal way, wanting to stay a step ahead of any legal measures taken by Varga's lawyer by announcing the death himself, but he couldn't find either of the millionaire's legitimate daughters. In the end it was the family lawyer who found Lujza and Anasztázia. The former was discovered in a Munich cemetery, having been dead for more than ten years. The latter continued her travels for a further two and a half years before she found out about her father's death. She had written just

one letter during all that time, when her father was still alive. The lawyer was finally able to contact her in Daho-mey, in Hotel Lagos. She didn't seem bothered by the news, because she continued to travel for some months and never returned to Dresden. Somehow, Anasztázia did receive a part of the Varga inheritance, though not a great deal: some money from sales, some money in the bank and some properties in Paris, Strasbourg, Frankfurt and Nuremberg.

Kokoschka's Doll

ADELE VARGA

CHAPTER 13

She took out a cigarette. Leaning against a wall, Adele took out a cigarette.

CHAPTER 21

Adele Varga had a grandmother in bed. She was sick and there was little hope, or so the medical oracles claimed. She lay there, awaiting death, and yet she was the kind of person who, like some prize fighters, was capable of lying down so as to better strike at their opponent's legs. Anasztázia Varga was as tough as old boots, and her life was something to be maintained. She was not bedridden, as they say, but liferidden. Adele spent many hours at her bedside, mostly reading to her. Other times, she would listen to her grandmother's life story, a story longer than a segment of an infinite straight line. She often heard the part about how Anasztázia had fallen in love. She was on the boat back from Nigeria, having made the offering to Oshun, when she met a German man who was dark as a Spanish gypsy and who spoke subterranean words, the kind that enter people's souls through hidden tunnels. She said it was instantaneous, like the creation of the Universe, a personal Big Bang. Before, there was nothing,

then suddenly there was everything, Copernicus had made the earth revolve around the sun and the German (with a gypsy air) had made the Universe revolve around her. They spent several days in a religious fervour of endless sex. One day, he got out of bed in silence, dressed and left without Anasztázia realising what had happened. He left and never returned, but destiny had already been fulfilled. Four weeks later, Anasztázia found out she was pregnant. She never heard from Popa again. Anasztázia accepted this without ever accepting it. She would relive the memories of that love affair, incapable of happiness outside of those recollections. In Paris, she had married a law-abiding man with a law-abiding appearance. That marriage had brought her two children and various misfortunes. She never forgot those moments on the boat back to Europe. She was aware that those moments were magical because they were unfinished; they were an open book, an alternate fate, without the attrition of a life spent together. Great passions live off this lack of true intimacy. But for better or for worse, this passion was violent and vivid, and left her unable to live a life of tedium, with all the banality that demanded of her. After all those years, Anasztázia Varga continued to sigh for Mathias Popa. She was dying and her only pleasure was letting that name drop from her lips like ripe fruit, like ripe despair.

CHAPTER 34

MEMORIES ARE NOT ONLY KEPT IN THE HEAD, IN
THE WHOLE BODY, IN THE SKIN, BUT ALSO HIDDEN
IN CARDBOARD BOXES/TIDIED AWAY IN WARDROBES.

Adele listened many times to her grandmother's sighs,
and one day she decided: she was going to find that man,
her grandfather. Alive or dead. She went over to the ward-
robe, to the cardboard box where memories are kept, to
see if she could find any clues. These amounted to a post-
card with KENOMA & PLEROMA LTD written on it, and
the name Mathias Popa on the back, along with another
card, from an Italian restaurant, with a simple "I love you"
written in permanent ink.

Just the way love should be written: in permanent ink.

Now in possession of a company name and a decla-
ration of permanent love, she decided to track down the
owner of that postcard and of her grandmother's heart.
She could find nothing, so she hired a detective. There

was no ceiling fan in his office, nor any vertical blinds. The man did not wear a gabardine overcoat, in fact he did not even smoke. It was not like a film at all. Filip Marlov was a sturdy man, with a long chin and a boxer's nose. He wore denim jeans, tennis shoes and a suit jacket. Adele told him her grandmother's story and gave him a card and some money. Marlov accepted the job.

"I accept," he said.

Adele smiled vaguely and said she was glad. She wanted quick results. There was no time to lose. She would pay more, if necessary.

CHAPTER 55

Filip Marlov filled his pockets with sweets from the plate on the counter of the second-hand bookshop. The morning light was rushing in through the rows of bookshelves, sending the dust flying. There were arched, stone windows, with coloured glass in the upper sections and books lying on the sills. The wooden floor creaked.

"I've come to speak to Agnese Guzman."

"I am she," said the woman behind the counter. "Can I help you?"

She wore a white apron and held a cloth in her hand. Her glasses, which hung off her nose, were dirty. Marlov could see that clearly. Two distinct fingerprints on the left lens, some dust, one smudged mark, another dark one, and more fingerprints on the right lens.

"My name is Filip Marlov. It's about that matter we spoke of, the book . . ."

"Yes, of course. I'll go and look for it."

The detective drummed his fingers on the countertop.

He smoothed his hands through his hair – which, despite being black, was milky-white – and went back to rapping his fingers. Agnese Guzman came back holding a book. The cover image showed some concentric circles, ten of them cut through by a ray of light coming from the four Hebrew letters which spell the name of God. The edition was from 1978, published by Kenoma & Pleroma Ltd. Marlov read the title – *Tzimtzum!* – as he took the book.

"Would you like some tea?" she asked.

"No, thank you."

"I'll get the pot."

"There's no need."

"It's for me."

"Of course."

Filip Marlov looked again at the book cover in his hand. Agnese Guzman walked away. The floorboards barely creaked. She returned with a steaming teapot and served herself. Her glasses fogged up.

"Are you sure you don't want any?"

"I'm sure, thank you."

On an impulse, Marlov pulled out a cloth and handed it to Agnese Guzman. Smiling, she took off her glasses and cleaned the lenses. The detective leafed through the book.

"There's an envelope inside the book," Marlov said. "Someone must have left it."

"It's part of the edition. Initially I also thought some-one had left it, but it's part of the book."

"Strange."

"The envelope contained an additional chapter, as well as an epilogue revealing the murderer's true motives."

"The murderer's motives?"

"Yes. It's a true story, as you will discover in the introduction. Or so the author claims. Do you know, Mr Marlov, we see the world through dirty lenses. Even when we are wearing spotlessly clean glasses. Here is your cloth."

"How much is it?" he asked.

"It's written on the book."

He took out his wallet and paid. He waited for her to wrap the book and hurried off.

CHAPTER 89

Adele walked up the shining stairs that led to Filip Marlov's office. The décor was so ridiculous it would have been out of place in a five-star hotel. Adele sat down in a waiting room with a television and some out-of-date magazines. It was as if she was waiting for a dentist. The secretary was a woman of around forty years, with thick-framed glasses and yellow dyed hair. The skin beneath her eyes drooped unflatteringly. Her ears were excessively decorated with golden earrings.

"You may enter. Mr Marlov is ready to see you," she said, still filing her nails as she entered the room.

Adele Varga went into the office and sat down. Filip Marlov greeted her, rising with a slight bow.

"Well?" Adele asked, in her no-nonsense way.

"I found a book from that publishing house, Kenoma & Pleroma Ltd."

Adele took the book. The cover displayed an image of the creation of the Universe, the publisher's logo, the

name of the author, Joaquim Hrabe, in black letters, and the title, *Tzimtzum!*

"It wasn't easy to find a copy. Finding such objects is not my speciality."

"Books," Adele said as she leafed through *Tzimtzum!* "That's the name we give to such objects."

"Right. As I was saying, I'm no specialist. I began by talking to someone who moves in those circles, and they put me in contact with someone else who in turn gave me the number of—"

"Yes, I get the idea. What else did you find apart from this book?"

"Nothing. I looked for books from that publishing house because I was unable to find any relevant information about it. It appears to have no physical existence. I found places linked to certain events, but nothing more than that. I contacted the people responsible for the places to which the publisher had travelled, but no-one could give me any useful information. I managed to obtain two addresses, one in Spain and another in Belgium. I found out that the Spanish one does not exist and never did, and that the Belgian one is a chocolate manufacturer established more than eighty years ago, eighty-seven to be precise (they brag about this a great deal, and justifiably so, that's a long time to be making sweets). Give me another week. I'll find the whereabouts of this Hrabe fellow."

CHAPTER 144

The following week, Adele Varga walked up the stairs to Filip Marlov's office. She smoked as she went, and wore a white hat that had belonged to her mother. She greeted the secretary, who made her wait a short while. Adele sat down with her legs crossed, the one on top rocking back and forth. After ten minutes, a client left the unglamorous detective's office, a sweaty man in a flannel suit. He looked happy about the meeting he had just had. He left a trail of odour behind him on his way out.

Adele went into the fan-less office. Marlov was wearing a leather waistcoat over a white T-shirt. On his wrist could be seen a tattoo of a dragon, most likely drowning in that sweaty room.

"Any news?" she asked, after shaking the detective's hand.

"Well, it's not an easy case. The name used by the author of the book I found for you, *Tzimtzum!*, must be a pseudonym.

"It's impossible to contact such a person: as I've recently discovered, a pseudonym means an uncontactable author. It's like one of those signs we hang from a hotel-room door handle, you know, to keep the cleaners away from our unmade bed. It's an occupied sign, that's what a pseudonym is, it means stay away. We know the person is somewhere inside that name, but we can't even take a peek through the keyhole. It was a busy week, trying to find bits of information through booksellers and so on. And I must tell you that I did a good job, because I discovered a man who has several books published by Kenoma & Pleroma Ltd in his possession. One of them is a travel book called *Journeys Beyond Death*, written by one Moisés Kupka. Let me look at my notes: it's a book in which the author describes his journeys around the world, visiting tombs and cemeteries. There's a second one called *Divine Contraction*, which is by an individual called Nicolau de Cusa. I investigated this person to see if I could find an address or telephone number, but he lived during the Renaissance, an era without telecommunications. I found out that this Nicolau was a philosopher and that the book is a translation from Latin. Last of all, there is a third book, with a different publisher, but the man, the book's owner, swears it belongs to Kenoma & Pleroma Ltd. It's a poetry book by one Ladislau Ventura, a Portuguese poet. From what I was able to investigate, this author is also as slippery as a bar of soap."

"Is this man selling the books?"

"No. He seems very attached to them."

"So what you're saying is, in a week's work you didn't find a single piece of worthwhile information."

"That's not true. The man isn't selling the books, but this morning I went to speak with him in person. He lives nearby. He's a retired watchmaker, like God."

Marlov made a dramatic pause before continuing:

"He's related to a writer who lives in Morocco. An author who published with Kenoma & Pleroma Ltd."

"Do you have his contacts? Did you speak to him?"

"This whole business is very strange."

"How so?"

"Do you know a book called *The Club of Queer Trades*?"

"Never heard of it. Did you speak to him or not?"

"I called him, but I didn't understand a word of what he was saying. He spoke French with an Italian accent, though perfectly clearly. So clearly that I could easily understand that the content of what he said was incomprehensible. I'm no fool, Mlle Varga, which means that either we are dealing with a complex matter, or else the man is complicating things on purpose. This one thing, which he repeated more than once, stayed in my head: *The Club of Queer Trades*. I did some investigation and found out that it's the title of a book by one G.K. Chesterton. I bought the book and looked through it, but without finding anything worthy of further investigation. I believe

that the only solution is to talk to him in person. If you want me to meet him, I'll need money for the journey."

Adele didn't take long to refuse the detective's help.

"Give me the writer's address and I'll meet him myself."

Marlov did so, without any apparent reluctance. Adele said goodbye and left the office, leaving the scent of her perfume and one more cheque behind her. Her slender legs, sculpted like falling rain, gave her an air of extreme determination. When she got up and walked, with her slim body, her slim nose and her purposeful hairdo, she could not fail to impress any onlooker. The tension with which she arched her eyebrows, as if everyone else were her enemy, left a solid residue in the air, a sense of power. Adele was very skinny and short, but she gave the impression of being a skyscraper in a leather miniskirt. Filip Marlov could not resist clicking his tongue.

CHAPTER 233

Adele Varga hailed a taxi from Marlov's office and went straight to the airport. She bought a seat on a flight leaving for Casablanca in three hours' time. As she waited, she bought a hamburger, a wheelie suitcase, some undergarments that were rather too refined for her taste, a toothbrush and toothpaste, a bottle of gin (to wash the hamburger down), a box of Turkish cigarettes and two perfectly white T-shirts. She put everything except the hamburger in her suitcase and went through the X-ray machine, with her slender legs, her slender lips, her slender nose and her extremely straight, black hair.

She sat down next to a middle-aged man, who was reading a great number of newspapers and had a small black moustache stuck to his upper lip.

Adele walked off the plane into the Moroccan heat. She headed to an airline counter to buy a ticket to Marrakesh. After six hours, most of them spent sleeping in a plastic chair, she boarded the plane. It was small, carrying no

more than thirty passengers, with one seat on each side of the aisle and a propeller on each wing. It landed aggressively, as if it disliked the ground, but Adele didn't even blink.

She found a room in a *riad* two hundred metres from Djemaa El Fna square. Its prices were far more modest than they usually were for this kind of accommodation, but it wasn't offering the same services, a fact that was completely irrelevant to Adele. This *riad* had been recommended by the taxi driver, who claimed to be the owner's cousin. How close a cousin he did not mention, but Adele Varga still took his advice.

She slept for a while to recover from the two flights and then went out for a walk. It was a promising afternoon, with the heat showing some restraint, and Adele walked to Djemaa El Fna. She stroked two cats who welcomed her affection and wondered about the lack of dogs. In the square she was mobbed by children and drank some orange juice. Then she ate, and used the hotel telephone to talk to Nicolas Marina, the author of the book published by Kenoma & Pleroma Ltd. A gruff voice answered on the other end of the line. Adele agreed to have lunch the following day at a restaurant of his suggestion, in the new town.

CHAPTER 377

The big windows looking out onto Boulevard Mohamed VI did nothing to detract from the restaurant's seediness.

"Sometimes you eat better in places like this, with windows like this," Nicolas Marina said.

The food arrived, and the portions were as enormous as the windows. Marina ate with his hands, assisted by bread, while Adele tried to use cutlery. It was an unequal battle and it ended with two coffees.

"A man from Kenoma & Pleroma contacted me in 1962 to write a very special book. Everything about it was highly strange. I remember it perfectly. I'd just published my first book, which had met with some success. It was called *Orpheus' Egg* and it was part essay, part novel. A man came and knocked on my door in Verona, where I was living at the time, in a second-floor apartment on the same street where Romeo and Juliet had forged their Shakespearean plot and made the world sigh. The chap limped as he entered. Because of his lame leg I even asked

him: are you a lawyer or what? The man did not reply. He suggested I write some immense, vast books, impossible works. He wanted me to write the lives of people, imaginary people. Literature already does that, I told him. You don't understand, he said, this is completely different, we don't want characters, we want *people*, which implies the need for another kind of perception. We want characters who interact with real life, just like any other person. But that's impossible, I told him. I was a young, ambitious man, but to me this felt like doubling the cube, like a chimera, like angle trisection. He responded by showing me a cheque with an unrefusable figure written on it. So I wrote life after life after life. My first work for that publisher was a book called *The Reincarnations of Pythagoras*. It was one of my most successful failures.

"I still don't quite understand the nature of what he was asking you. What was the aim?"

"I can't really give you a good answer, because I stopped asking questions the moment I saw the cheque. What possible motive could there have been to pay me such an embarrassing sum just to write a book about the lives of people, and then write more books attributed to some of those people? I thought about it for many years, of course I did, but the only conclusion I ever reached was that it must have yielded sufficient returns. So I wrote the book *The Reincarnations of Pythagoras* and then I was, let's say, ordered to write books supposedly written by

characters from that book. I wrote three that were released
by different publishing houses, or by imprints of the same
one, and their authorship was attributed to the charac-
ters that I had created for the book *The Reincarnations of
Pythagoras*. This caused unimaginable levels of confu-
sion in the academic world. I was involved in court cases
and everything. But I hadn't learned my lesson, because
I then wrote a book that was even bigger than *The Re-
incarnations of Pythagoras*. You can't imagine how much
it consumed me. Coming up with so many written pages
was truly painful. But they asked for more and more every
time, and then I realised that it wasn't for me. I think
that man was trying to make me understand something
profound, but my mind refused to comprehend it. He'd
calmly utter some sentimental maxim, such as 'Wisdom
always brings harmony. Peace,' he'd say. He stopped short
of talking about love. I was always a subterranean writer,
a friend to rats and cockroaches; my writing has always
drawn breath from dark things and stairwells. Peace and
love are things I've always avoided. I'm no idiot, Mlle
Varga, but I swear I didn't understand it. He even asked
me to invent rumours and spread them. Rumours about
the characters I'd created. Imagine: whenever I wrote for
a newspaper I was supposed to bring up a scandal involv-
ing one of the people I'd dreamed up. As if it were true.
I found it all very confusing. He grew tired of giving me
reasons, but the whole thing seemed more like a religion

than a profession. He began to frighten me. With his limp
and everything. One day, when the man showed up with
more extravagant requests, I finally told him to shove
his cheque up his arse. I didn't want to know about it. I
was fed up and afraid. The truth is that I'd accumulated
enough money to be in a position in which I could order
cheques to be stuffed into dark holes or stairwells. But
you can't imagine the relief I felt. It felt like the Devil had
given me my soul back. That night I drank so much, my
hangover could be felt more than one hundred and eighty
kilometres from my epicentre."

"Do you have any copies of those books?"

"The ones I had ... I destroyed. Those books are
accursed things."

Nicolas Marina and Adele Varga spoke for a few hours.
They walked for a while along the river.

"Do you have any contact with that man or with the
publisher?"

"No: he is not connected to us, if you follow. We are
connected to him. That was their policy. The man was
called Samuel Tóth, but I never again heard speak of him.
Nevertheless, I kept receiving correspondence from the
publishing house, Kenoma & Pleroma Ltd. Advertise-
ments for events, launches, etc. I tore it all up. Nothing
good can come of that place. You will have noted that
when I sent the man and his cheque away, I was still living
in Verona. I made up my mind to leave the following year,

because my life in that city had come to an end. In fact, my life in that country had come to an end. It happened more or less by chance, because I had decided to take a holiday. I was devastated. I came to Morocco, got married eventually, and I'm still here, decades later. Now tell me: how do they know where I live? This is my third address since living in Marrakesh. And I spent two years in Rabat. How did those cunning swine get hold of my addresses? They have sent correspondence to every place I've ever lived here. They appear to be more efficient than the Treasury. It's rather frightening, don't you think?"

"So you don't have any of this correspondence?"

"None. But it's funny, because I always buy certain European newspapers, and in one of them, which happened to be French, there was an advertisement for an exhibition organised by Kenoma & Pleroma Ltd."

"And when was that? What was the exhibition's date?"

"It's already happened. It was in Paris, on the 17th of this month."

"I live in Paris."

"It was ever thus. Have you never heard it said that the thing we are looking for, the thing we desire the most, is always right before our eyes? But to see it we must travel hundreds of painful kilometres away from it. We're too close to see it. We must create the distance."

"Do you know where it was held?"

"I have no idea, Mlle Varga. You're entering a very

strange world. But if you look through last week's *Le Monde*, I couldn't say which day, you'll find the advertisement, no doubt about it."

Adele and Marina kept walking. It was a pleasant evening, and at a certain point – without any warning signs – Marina grabbed Adele, in a hasty and passionate movement, and kissed her. She responded by not responding at all, which left him furious. After a few seconds, Adele stroked his head the way you would a dog, and the writer turned around and left. Adele then entered a hotel on the corner to drink something alcoholic before going to lie down, but she couldn't enjoy it because of a group of nearby drinkers.

CHAPTER 610

Adele rose late the following day. She lit a cigarette and smoked it on the veranda as she gazed out into the infinite concentrated in an orange tree. Her slender fingers, trembling lightly, gripped the cigarette. She had a milky coffee in the inner courtyard of the *riad* as she wrote down what she considered to be the most important facts in a notepad. She decided she still had many questions and went to Nicolas Marina's house. He wasn't there. The door was opened by a tall woman who had a pleasant face, despite her threatening stature. Her name was Daniela and she invited Adele in. The two women sat down on an ample sofa and Daniela went to get a tray with a teapot and two cups.

"I met my husband in Casablanca. I'd just written a play for a Neapolitan theatre company and, being temporarily unemployed, I decided to travel. The first time I saw my husband was in a carpet shop. I helped him haggle. He had no skill for it, still doesn't. He doesn't understand

people, despite his ability to describe them in literature. Not knowing how to haggle is a mark of this lack of understanding. Anyway, his lack of know-how warmed me to him. It was a maternal instinct, you know how we women are: we burned our bras, but we never liberated ourselves from being mothers. We still feel an urge to protect men. And God knows they need it.

"In other words, I saved him from paying four times more than he should have for a poor-quality *kilim*. Then we got married."

"You left the carpet shop and got married?"

"Almost. We dated for seven months, but it's not much of a story. The same thing that happens to all besotted couples happened to us. And of course, that inevitably led to this."

Daniela made a sweeping gesture that took in the whole house.

"I don't regret it. Any other path would have led to something similar. It's my fate to end up like this, drinking tea and talking about the factory, lacking any and all inspiration to write. I feel worn out. But I won't bore you with my complaints. You probably didn't know, but we own a screw factory. Don't imagine that I mind about having exchanged literature for this. To tell the truth, screws are terrifyingly profound. Thinking about them can lead you to write philosophy. Heraclitus the Obscure said that the screw is the synthesis of the straight line and the circle.

Do you understand? When a screw moves, the circle and the straight line become one and the same."

"I see. Tell me about the books your husband wrote for Kenoma & Pleroma Ltd."

"*The Reincarnations of Pythagoras* is a fascinating book (I assure you, I'm not just saying that because he's my husband) about all the lives that philosopher claimed to have lived, from Aethalides, through Euphorbus (who was wounded by Menelaus in Troy) and Hermotimus, and finally to Pyrrhus (who preceded Pythagoras). We don't have any copies of the book because Nicolas, imbecile that he is, believed they were cursed and got rid of them. *The Reincarnations of Pythagoras* also included transmigrations that came after Pythagoras and some that preceded Aethalides. Almost all these lives are described in minute detail, making use of sources that go way beyond Diogenes Laertius and Iamblichus (in the sections that concern Pythagoras). The book had 3457 pages and was published in a square edition, measuring thirty-three by thirty-three centimetres. It weighed nearly six kilograms on an empty stomach. Academics cited the book over several years and it ended up being used as study material in several universities. That was until one Theóphile Morel, a professor of philosophy at Salzburg, denounced the book as a fraud: most of those biographies presented as reincarnations had no historical basis. After that revelation, the very same people who had admired the book for

being an impressive account of a series of important figures from Classical Antiquity started laughing at him and at the book, and eventually it met its fate: it was forgotten. But it was no easy battle. Some of the books that had allegedly been used as references for *The Reincarnations of Pythagoras*, which none of those learned men had heard of, did actually seem to exist. For example, there was a recent translation of a work by Simonides of Amorgos that had supposedly been lost for centuries, and Eudoxus of Oenoanda was mentioned in one volume as having been a pseudo-Zostrian. That is to say, my husband's inventions really existed: some of those works had been written by him, while others had been written by other people. The truth is, the gallery of authors created by my husband were actually being published, and this was confusing to many. Samuel Tóth, from Kenoma & Pleroma Ltd, asked other authors to create the works cited in the bibliography to *The Reincarnations of Pythagoras*. Dozens of convincingly written books appeared, published as classical works, which complicated the conclusions that had been drawn. And as if that wasn't enough, there were also authors and students outside that infernal circle who, having been tricked, further confused things by citing innumerable authors who were nothing more than fantasy in their essays and theses. The verses of Eudoxus of Oenoanda, for example, were used as a source on many occasions. That was why it took so long to discover that it was all an

invention, a fraud. My husband was accused of that and of many other things, including of being the author of works he hadn't written and which he didn't even know existed.

"We hadn't met at that point, but he told me the story more than once. In despair, he tried to insist that he hadn't written the books which supported his invented bibliography. The whole intrigue was so complex that his work even won prizes. Some of them were real, but three of them were invented by someone, most likely that sinister editor from Kenoma & Pleroma Ltd, Samuel Tóth. Once we received news that my husband had won a prize, worth five thousand dollars and awarded each year to the most impressively rigorous historical study by the University of Odessa, in collaboration with the Department of Culture. It later turned out that this was another non-existent prize (of course it was!), and nothing more than a fake press release. The university didn't even award such a prize.

"In other words, the books that were published as translations of ancient texts were merely made-up works attributed to the names my husband had invented in the bibliography to *The Reincarnations of Pythagoras*. They had been written by other anonymous authors and published by the same publishing house, which in these cases was not called Kenoma & Pleroma Ltd, but went by other names, as if they were different entities.

"But that's not all. My husband had also written *The Book of Heteronyms*, in the same style as the previous

Mathias Popa

work. He wrote it straight after, more than two and a half
years of uninterrupted work. He has many defects, but
he's like a living typewriter. *The Book of Heteronyms* was
an immense work, three times bigger than *The Reincar-
nations of Pythagoras*. It contained life after life, written
on Bible paper in a seemingly infinite rosary. In that work
Fernando Pessoa, the creator of the concept of the het-
eronym, was himself a heteronym, who happened also
to be the heteronym of another heteronym which could
be, for example, the heteronym of Álvaro de Campos. My
husband made a labyrinth from all these lives, and in the
opening pages the entire genealogy was laid out in a dia-
gram which was itself completely incomprehensible and
impossible to follow: some of the names were written in
type so tiny it was illegible, while others had lines going
through them, making any attempt to decipher them
futile. Even the lines linking some names to others were
so numerous and were extended across so many pages
that they became impossible to follow. We were often un-
able to choose which road to take at a junction, as there
were so many intersections. Suffice to say, that diagram
contained the names of nearly five thousand people.
Five thousand, think about that. The full account, which
spread over nigh on two thousand five hundred pages
(Bible paper) contained even more characters (almost
thirty more), meaning that the diagram itself was not fully
comprehensive. And in several extreme cases, which I've

already mentioned, an author had created a character who had created another character who had in turn created the author himself. It was a circular, or rather spiral-shaped system, which made it hard to decipher. The legend on the diagram itself mentioned that it had to be understood in three or more dimensions: the two-dimensional design could not properly display all of the existing relationships in space or in time. Do you think that this labyrinth was my husband's idea? You're wrong. It was Samuel Tóth who came up with this intrigue. And what was the intention behind all of this, according to him? To create lives. 'What for?' I asked him (my husband never told me anything). And Samuel Tóth laughed."

CHAPTER 987

The charmless detective answered the telephone. Adele Varga called him from Marrakesh with another small job: to find an advertisement for an exhibition organised by Kenoma & Pleroma Ltd in a *Le Monde* from the previous week.

CHAPTER 1597

Back in Paris, Adele went over to her grandmother's house. She spent the day in a bad mood, suffering from a slight headache and feeling that she had got herself too deeply involved in a stupid and costly search. Rather romantic for someone of her temperament.

Adele had rented an apartment, but due to her illness she was practically living in her grandmother's house. She went home only to tidy up, check her post and little else. In any case, her grandmother's condition was continually worsening. Her eyes were sinking into a past that had been transformed into wrinkles. Her bony hands trembled continuously. Adele's space/time continuum could be summed up as follows: less and less space for her, and more and more time dedicated to her grandmother.

Before she entered the bedroom she smoked a cigarette, leaning against a chest in the corridor, where a photograph of her parents was on display.

When Marlov gave her the location of the exhibition,

Adele drove straight there. The road twisted and turned, but time passed in a straight line. She found a car park and walked a few metres. The building holding the exhibition rose up before her on that rainy day, a day of heavy rain that struggled its way through the air, battering the wet ground. Adele entered an art gallery. A bearded, bald man greeted her with a smile. They introduced themselves and Adele explained the reason behind her visit. The bearded, bald man said that the exhibition had not taken place. The artist had never shown up with his work. But he had some information about the event. He handed Adele three newspaper articles containing the following texts:

1

GUNNAR HELVEG: AS ON THE OUTSIDE, SO TOO ON THE INSIDE

Man (and I include the reader in this sketch) has long struggled to choose between the idea of a handsome, young, seductive devil, and that of a limping one with tail and horns. Nevertheless, it was decided at the Council of Trent that the spiritual ugliness of the Father of Lies should correspond to his appearance. It was a diabolical decision, one that had already tempted the Creator of the Universe himself one afternoon, as He pondered the

first chapter of Genesis (it was this chapter, Holy Mother Church says, that inspired Him to create the Universe rather than Nothing). Now, at the Beginning of Beginnings, Elohim found himself creating a venomous group of animals whose appearance did justice to their wickedness. He probably regretted this, but after the famous Council of Trent he was urged to maintain the production line and match physical horror to intellectual monstrosity: a cruel psyche must be manifested in an equally frightful soma, or body. The outside of a minister should clearly manifest the inside of a minister, so as not to deceive anyone. But the truth is that appearance often radically deceives. In other cases God manages to obey the Council of Trent's decision, and when we look at a statesman we can immediately see the statesman inside him, perhaps even a president of the Republic or a member of parliament being interviewed by an ex-model (I have myself often experienced such phenomena, where what is on the outside resembles what is on the inside: for example, sometimes I have felt pain in my soma, only to discover it originates in my psyche). As previously mentioned, it is very difficult to maintain this correspondence between soma and psyche, and the Creator of things past and future was unable to maintain a convincing level of homogeneity and so allowed into the world – this vale of tears – innumerable contradictory cases in which, for example, a hunchback can show great intelligence and bonhomie (Socrates, the

philosopher, was very ugly. He wasn't hunchbacked, but he was very ugly); at the same time, there abound cases in which physical beauty brings with it great stupidity, or even an entire Miss Universe.

(Ari Caldeira, *On the inside and the outside*)

2

INNER BEAUTY
(THE SPECTACLE OF THE SOUL)

Gunnar Helveg organised this exhibition of tomographies of the brain, something that cost him his job. During positron emissions, Helveg asked patients to think about a Dylan Thomas poem or an extract from Rilke. Or a haiku by Masamitsu Ito or a short verse from the Canticles, or even an Abokowo song. "If the thought is in some way beautiful then the tomography will also show harmonious colours and forms with pleasant curves and tones, like an abstract masterpiece. It cannot be otherwise. What is on the inside is like what is on the outside. I capture the inner layers of the most beautiful thoughts and display them translated into colours, just as they were originally conceived. I was the first person to photograph a beautiful thought," Helveg says.

3

IMAGES OF THE BRAIN

Using functional magnetic resonance imaging, tomographies and X-rays, Gunnar Helveg has created a singular exhibition: a former doctor now dedicating himself to photographing the brain and to trying to capture the exact moment at which a brilliant idea occurs.

That idea is expressed in the photographic colours as a work of art, as a masterpiece of abstractionism, with balanced and harmonious forms. If the idea is good it will also express itself beautifully, in the heat which creates the medical image. If what is on the inside is beautiful, its outward manifestation should correspond to that. It must also be beautiful.

"Is there any way you could put me in touch with Mr Helveg?" Adele asked the bearded, bald man.

"If only. I spoke to him on the phone but in the end I lost track of him. I wasted a lot of money, time and availability organising this non-exhibition. If you find him, please bring him here. I've got a bone to pick with him."

Time passed, but for Anasztázia Varga it passed more emphatically. That morning the doctor had called Adele telling her not to go far, as the death of her grandmother, that angel full of eyes round about, was imminent. Because of

this Adele could feel that pressure on her chest, between her heart and her soul. She had to find her grandfather, not so much out of actual necessity as her panic forcing her to act. She got into her car without knowing what to do. The minutes and the hours were beating down against her windscreen.

She called Filip Marlov the moment she got home, feeling worn down. Marlov had some good news. He had found Samuel Tóth, who was living in Budapest. If she wanted, and if there was a cheque involved, he would leave that same day for Hungary, to talk to the owner of Kenoma & Pleroma Ltd. Adele would have liked to have chosen a different option, but she was just so tired. She made up her mind:

"Do whatever is necessary. I'll pay for whatever is necessary."

The last part of
Kokoschka's Doll

SAMUEL TÓTH

CHAPTER 2584

Samuel Tóth arrived, bearing his customary solemnity, albeit rolled up in a certain sense of hesitation. They walked a few blocks, Tóth not saying a word. Filip Marlov, who could not deal with wordless dialogues, found the silence constraining.

It began to drizzle. The castle could be seen on the other side of the river, along with some irreproachable, ashy-grey clouds hanging in space. Marlov opened an umbrella and invited Samuel Tóth to shelter beneath it. Tóth turned down this friendly gesture in a friendly manner and kept up the same pace while Filip Marlov struggled with the wind that blew against his umbrella.

"Today," Tóth said between raindrops, "I'm going to show you a most impressive space."

Marlov made no comment.

They stopped in front of a building with a Neo-gothic façade that was even blacker than the weather. It had been built at the beginning of the twentieth century by the

architect Imre Lakatos. The building had ogival arches and ridiculously pompous ornamental stained-glass windows. Lakatos lived deep within the nineteenth century and moved among the most select circles of Budapest society. He formed part of a certain Magyar bourgeoisie that was in the habit of discussing metaphysical problems and drinking Eger valley wine in palace cellars. Lakatos designed the building on that central Budapest road at the behest of an extremely rich, conservative and angry man, whose prosaic objective was to put a roof over the heads of all the offspring he had brought into the world. Zsigmond Varga – that was the millionaire's name – was a lifelong lecher and had fathered several children by several women. So he ordered the construction of that building, with seven floors and two apartments per floor, to house all of his (let's call it) legitimate family. In addition to this building, which would be home to around seventy people, including children, sons- and daughters-in-law, grandchildren and great-grandchildren, Varga was planning, should fate concur, to build a neighbourhood behind that house where his other children, who had reached more than forty in number, would live. Including all of their respective families, that would total more than one hundred and twenty people.

"Varga intended that this building would establish a special hierarchy in his family, one planned by him, which reserved the highest floors for the children in whom he had the least hope."

"Why the highest ones?" asked Marlov as he shook his overcoat.

"There were no lifts at the time. Also, only the ground floor had an organic relationship with the outdoor spaces and the exquisite, Victorian-inspired garden."

Tóth pulled out a bunch of keys and selected one. Slowly, he introduced it into the lock and turned it with a click. The door opened and the two of them entered. Filip Marlov, a hard man, was trembling on the outside and on the inside. The darkness did not help the murkiness of the situation. And yet Tóth advanced as if everything were illuminated. They walked down a damp-smelling corridor and stopped before another door. It was made of iron and painted green. Tóth pulled out the keys again. He selected a key in that meagre light and opened the door. They went up two flights of stairs and stopped at a landing that ended with two arched doors. He repeated the ritual again. Another key was produced, another door opened.

CHAPTER 4181

THE FACE OF GOD IS AN INFINITE MIRROR

"He collected butterflies."

"Who?"

"Zsigmond Varga. He had an enormous collection which now belongs to the Dresden Museum. At one point, Varga claimed to be able to weigh sin."

"How?"

"Did you know, Mr Marlov, that we are lighter when we wake up than when we go to sleep?"

"There's a perfectly rational explanation for that."

"I'm sure there is. At least, Varga thought so: he believed that sleep cleansed us of all the evil we commit during the day. The sleeping hours are ones in which the soul is cleansed. That's why we dream. Dreams, for Varga and, curiously, for science too, are nothing more than that day's waste. That is to say, the things we don't need. For Varga, that was Evil, the sin to be purged, wiped clean.

That explains why we weigh more at night than when we wake up. At night we're full of the sins we have committed that day, and in the morning we are, how shall I put it, clean."

"How absurd."

"Perhaps, but Varga dedicated years to his theory. He weighed thousands of people, in the morning and at night, and compared the data."

"You're not exaggerating, Mr Tóth? Thousands?"

"Absolutely. Half of that figure was made up of women he hoped to seduce, but much of his data was gathered from his family. Meticulously filled-in notebooks. For him, the difference between the morning measurement and the evening one was the weight of Evil."

Tóth picked up his black leather bag, which he always carried with him, and took out some stapled sheets of paper. He placed them on a chair and went back to rummaging through his bag. He took out his glasses and carefully put them on. Then he began to read:

"'After realising that a man is heavier at night than he is when he wakes up, even if he's eaten nothing during the day and voided according to his will and need, I resolved to write this book on the weight of Evil.'

"That is the first sentence of his unpublished notebooks. The first chapters are dedicated to this difference between the morning and evening weight. As I've already told you, Varga affirmed that this difference, which can

be as high as several kilos, is due to the weight of the Evil one accumulates over the course of a day. Both through actions and through omissions. In many aspects Zsigmond Varga's entire sketch is emasculating, prudish and conservative in tone. It makes it harder for us to classify him as a mere profligate libertine, doesn't it, Mr Marlov? It shows that we are all made of incoherencies, of opposites."

Marlov rolled his eyes impatiently. Samuel Tóth straightened his papers and cleared his throat before starting to read another section:

"'Because he continues to accumulate sins throughout the day, when night comes the common man is full of little devils which have infiltrated his blood, his flesh, the folds of his skin, the space beneath his nails. That is why gambling, prostitution and crime are more common at night-time, after the sun has gone down, when the body is most weighed down with peccadillos, defamation; in short, when it is most blended with Evil.' In the last decade of the nineteenth century, in 1897 to be specific, Varga decided to carry out the following experiment, the first of its kind: he placed one of his servants, an adolescent of Slavic origin whom Varga had got pregnant two years earlier, on a scale, together with their child. He ordered the girl to undress and then to take the child's clothes off. All this was meticulously described in these notebooks. Would you like to read, Mr Marlov?"

"I don't think it's necessary. But please, continue."

"Once his subjects were completely undressed, he made the girl kiss the child. Then he asked her to slap him. He weighed the two actions and claimed to have obtained different results. The scale measured two more grams on the second action, the one where the 'devil's finger' could be felt. And he concluded: 'The surprising thing is not that one is heavier at night, but rather that there are any mortals in the world who do not lie down at the end of the day weighing the same as two or three African elephants. (. . .) A man weighs 4% and a woman 5% more when they go to sleep, compared to the moment they wake.'"

"That's a rather sexist conclusion."

"Not every inhabitant of the nineteenth century was capable of holding the modern views of the following one. In any case, Varga felt he was acting in good faith. For him, the results he recorded were precise, objective, true. It goes to show, Mr Marlov, the extent to which our convictions mould the world around us and the extent to which we can make ourselves believe the lies we tell ourselves. We force the world to be the way we believe it is and don't even realise how much of our lives we spend lying to ourselves. All of us, yourself included. This is one of the most tenacious human characteristics. Have you ever heard of Nikolas Hartsoeker? The seventeenth-century anatomist who learned to make microscopes? His more or less pioneering observations of semen led him to conclude that in each spermatozoid's head there exists a fully formed

homunculus. Imagine, dear Marlov, a tiny man curled up in the head of a spermatozoid! Now, this homunculus, being fully formed, was in possession of gonads, that is, a complete set of sexual organs. And inside his testicles were spermatozoids. Inside these spermatozoids, in their heads, there lived more homunculi, all curled up. It's like a game of mirrors stretching out to eternity. In fact, it went all the way back to Adam. In the book the anatomist published in 1694, the *Essay de Dioptrique,* there is an engraving with an image of the homunculus in the foetal position, nesting in the head of a perfectly disproportioned spermatozoid. Hartsoeker was a Christian and what he saw through the lens of the microscope he also saw through the lens of what he believed a good Christian was. We all possess innumerable such lenses. Microscope lenses, telescope lenses, the lenses of democracy and Christianity. But allow me to continue: Varga went much further in his search. He began to weigh the dying. Whenever someone was dying he would pay the priest to let him take them away. His objective was to weigh people immediately after they expired. He wanted to weigh the soul. He always had a carriage ready to chase a person's last moments. He would cross the city, holding his top hat, with five servants and a gypsy violinist who never stopped playing."

"A violinist? To make the death throes more comforting?"

"Of course not. Such sentiments were completely

absent in Varga. The violinist merely represented his wish to spend his whole life listening to music. He used him in so many situations that it would be difficult to list them here. The choice of musician was no coincidence: the violinist was blind. That allowed Zsigmond Varga to be with his lovers and listen to him playing without the musician seeing what was happening, needless to say. For some reason, he wasn't the slightest bit bothered by the fact that the violinist could hear what was being said in those moments of great intimacy."

"How vile."

"In any case, what's certain is that Zsigmond Varga travelled across the city clutching his top hat, with his head sticking out of the vehicle while a violinist played. The carriage was equipped with a hydraulic scale, very sophisticated for the time, capable of raising up the dying person's bed and then subtracting its weight. That way they avoided the inconvenience of having to move the person onto the scale. The mechanism functioned with a crane that went under the dying person's bed and lifted it a few centimetres from the ground, enough to be able to fully take the weight. The scale was carried by four of the five servants who always accompanied him. The fifth servant's job was simply to drive the carriage."

Samuel Tóth adjusted his glasses and cast his eyes towards Filip Marlov's features. After returning his papers to the black bag, he continued:

"Varga took care to weigh the dying people when their lungs were empty, immediately before and immediately after. And to see what the difference was."

"Is there a difference?"

"Yes, there is, according to Varga. A very small one, so small that he decided, with a certain poetic touch, to measure that weight in butterflies rather than grams. As you know, he was a fanatical collector of butterflies."

Samuel Tóth took the papers from his suitcase again:

"In the conclusion it says the following, and I quote: 'The difference between life and death, the weight of the soul, properly put, is that of a *Papilio demodocus*.' The *Papilio demodocus* was his favourite butterfly. For him, the difference in weight between a lifeless and a living body was the equivalent of an African butterfly. That was the weight of the soul, which he believed he had discovered. Of course, everyone thought he was mad, but they tolerated his eccentricity because he paid generously for these activities. And his investigations didn't end there. At one point, he requested that extremely precise scales be placed in confession booths, so that people's weight could be measured before confession and after the sacrament. It was another one of his attempts to measure Evil.

"Completely mad."

"Aren't we all, Mr Marlov?"

CHAPTER 6765

Samuel Tóth wiped his sweat-drenched hands on his trousers before continuing with the story of the Varga family.

"In 1912, Zsigmond Varga's business dealings led him to emigrate to Germany. Once there, he ordered the construction of a house identical to this one but built from white stone. A black one in Budapest and a white version in Germany. A few years after the move, which took place in the summer of 1918, his oldest legitimate daughter was caught in bed with a gypsy. She was fourteen years old and the gypsy in question was the blind violinist who, it turned out, could see perfectly. He was called Ovidiu Popa and Varga had brought him along in the move from Budapest to Dresden because, in his own words, "he was the most indispensable of all my servants". It wasn't easy to find a violinist of that quality, let alone a blind one. So when Zsigmond Varga saw the violinist on top of his daughter he went into a blind rage and grabbed his stick with one

hand as he clutched his chest with the other. Unable to choose between dying of a heart attack and killing the lovers, he opted instead to take a few breaths. This gave Ovidiu enough time to escape through the window of the mansion where they lived in Dresden. Lujza wasn't as cunning as her lover and stayed there, sobbing and gripping onto the sheets. Varga went to work on his daughter's ribs with his stick and she fell from the bed onto the street, completely naked. She heard the door close behind her and, in a frenzy, ran until she found an open window.

"When God closes a door, He opens a window," Marlov said.

"You know, Mr Marlov, this talk of God means nothing to me. I don't believe in that way, the way other people believe. For me, if God opens a window it is to let in the air. I don't expect anything good to come from the existence of a being that doesn't exist. Besides, the saying would be more accurate if it was: when God closes a door, He opens a window, which is how the thief gets in. Listen to Lujza Varga's story and you will see that I am right."

Marlov adjusted the buttons of his jacket.

"First I'm going to tell you about Oscar Kokoschka."

"Who?"

"You've never heard of him?"

"Did he write that ballad . . . ?"

"No. Kokoschka was a painter, among other things of a broadly expressionist nature, born in 1886. His passion

for a woman named Alma was so great that as a historical fact it puts any work of fiction to shame, be it by Shakespeare or anyone else. Nothing like it has ever been witnessed in all of history. Pay attention, Mr Marlov, for love can be stranger than you think. Oscar Kokoschka lived in Dresden and was born in Pöchlarn. He left Dresden in 1934 because the Nazis didn't like him. The feeling was mutual. But by then one of the most romantic episodes of all time had already happened: Kokoschka and Alma."

CHAPTER 10946

"Alma was Klimt's first kiss," Samuel Tóth said, "she was Alexander Zemlinsky's lover, then she married Gustav Mahler. She became Gustav Mahler's widow. She married Walter Gropius and others. No sooner had she become Gustav Mahler's widow than she began a febrile romance with Oscar Kokoschka, which lasted for three years. At times his family could not hear him through the shouting. He howled for Alma. His mother suffered greatly, Kokoschka said. And Alma had huge repercussions in the artist's life. When she ended the relationship, Kokoschka was devastated.

"He gathered together various pictures he'd made which depicted Alma," Samuel Tóth continued, "and asked the dollmaker Hermine Moos to make a life-size, identical doll of Alma Mahler; an absolute replica, with nothing changed at all. The instructions given to Hermine Moos (included in a letter and in several sketches) had mathematically rigorous descriptions of his lover's

body: the folds of her skin were described in fine detail, all her hairs counted. I do not believe such passion has ever been witnessed, not even in fiction. Note, Mr Marlov, that the instructions included very small details such as folds around the groin or the consistency of her skin to touch. Kokoschka did not leave out a single detail. And he chose a skilled professional, Hermine Moos, to carry out his request. If all this seems crazy or made-up to you, Mr Marlov, then prepare yourself for what he did next."

"I'm curious. Can there be anything more insane? A man falls in love and gets a doll made to replace a flesh-and-bone person?"

"Listen to me carefully, Mr Marlov. We are all puppets; some of us are more doll-like than others, some of us are more widely venerated than others. What's certain is that the doll was made and turned out, I think, to be a disappointment. Kokoschka ended up killing it. But I'm getting ahead of myself. For some time, he made it live. It's not only having a body that makes a person exist. They need a social life. They need words, a soul. We need witnesses, other people. Because of this, Kokoschka made his servant spread rumours about the doll. Stories: as if she existed, as if she had an existence that was similar to our own."

"How demented."

"You really think so?"

"Evidently."

"Then you couldn't be more mistaken. Existence is

composed of witnesses, endorsements, stories. Do you know that Buddhist riddle about the falling pine tree?"

"No idea."

"Imagine a pine tree falls and no-one is around to hear it. Does it make a noise?"

"Very clever."

"Alright, forget about the pine trees. What is interesting is that no doll can come to life without the 'other'. It needs witnesses, confirmation. Oscar Kokoschka did just that. He took it to the opera, walked it through the streets and gave it a life using his rumours. Have you ever heard of a love like that? Bringing a creature that is a replica of your love to life?"

"No . . ."

"One day, Kokoschka moved beyond this phase (let us call it that) and invited some friends over for a party, during which he smashed a bottle of red wine over the doll's head. The flame of his love had officially gone out. Later on, the police appeared after seeing the dead body of a woman in his garden. Once the matter was cleared up, the corpse (can we call the remains of passion a corpse?) was thrown into the rubbish. The body, the head, the clothes."

"That outcome doesn't surprise me."

"It doesn't surprise you because there was no outcome. A man called Eduwa, originally from Nigeria, found the spoils of love and took them to his house. Eduwa worked as a gardener for a German woman whose name is of

no relevance to this story. All you need to know is that Eduwa lived in a small brick house, built on that woman's property in the outskirts of Dresden. He cleaned up Kokoschka's doll and put the head back onto the shoulders. He dressed it with its clothes and began to adore it in the same way it had been adored before. What a coincidence, Mr Marlov. What a miracle. He thought of the doll as a goddess and offered it flowers, fresh water, milk and other things I couldn't detail. Eduwa believed that the doll was a manifestation of Oshun, a goddess from West Africa, the region from which he originated. Note how little difference there is in the way an atheist like Kokoschka and a believer like Eduwa both treat a doll. It makes you think about atheists and believers, doesn't it, Mr Marlov? But let us take up the narrative again. Do you know the myth of Pygmalion?"

"I know the name, but please don't ask me to tell you the story."

"Pygmalion was a sculptor who made a statue of the ideal woman. He fell in love with his creation and Aphrodite brought the stone to life. The statue came to life."

"You're not going to tell me that you, a fervent atheist, believe Kokoschka's doll came to life?"

"Perhaps, Mr Marlov, perhaps. But not the way you think. The truth is always far stranger. That's where Lujza comes in. Through Eduwa's window. When God closes a door, He opens a window, remember, Mr Marlov? Lujza

entered his house naked while he was sleeping. When Zsigmond Varga's daughter saw the doll, she took off its dress and put it on herself. She threw the doll out the same way she had come in, through the window. An understandable gesture of rage. The noise woke Eduwa and what he saw left him open-mouthed and silenced: the goddess Oshun was alive. She was there, kneeling before him. His feet trembled and he fell to the floor, so that he was the same height as the fallen goddess. For all the time they lived together he continued to venerate that woman as he had done with the doll: with flowers, honey, milk and prostrations. He loved her more than can be imagined. Anybody can love another person, but Eduwa was living with the divine. To get an idea of it, dear Marlov, to get an idea, just imagine a nun suddenly finding herself sharing her home with Christ. Imagine if all their love and devotion became a person. God made man. It doesn't make the love any greater, but it does make it tangible, within reach."

"That is the miracle of Christianity: turning the human divine."

"Perhaps, Mr Marlov, I won't argue with that, but the truth is that Eduwa was able to experience a goddess of flesh and bone. Viewed from the outside, it couldn't be worse. That woman treated Eduwa like a slave. She always looked down on him and never even let him touch her. Nine months later, she had a son."

"Which wasn't his, of course."

"Why do you say that? Aren't you a Christian? An immaculate conception would be credible."

"Don't be ridiculous, Mr Tóth. I'm not a Christian."

"What about the cross hanging from your neck?"

"We all carry a cross. The fact that I carry mine on my chest means nothing."

"Alright then. What happened was that Lujza had got pregnant by the gypsy, Ovidiu Popa. But from Eduwa's perspective, it was his son, the fruit of a miracle similar to the one in which you do not believe. An immaculate conception. The child was baptised by Lujza with the name Mathias, to which she added the biological father's surname."

CHAPTER 17711

"Eduwa tried to be both father and mother at the same time. He taught Mathias some of the tenets of his native religion, for he knew all of Nigeria's Voduns, as well as the offerings and plants dedicated to each god, in other words, information that was rather distressing for a young European, and his education was of little use to him on the streets of Dresden and in the poverty of his childhood. As for Eduwa, he always believed that Mathias was his son, mysteriously generated, perhaps in a dream. For Eduwa, the child was the fruit of his devotion, of his word, in short, of his love. And who are we to deny that children are born from that?"

Filip Marlov felt uncomfortable. Tóth went on with his story.

"He persisted in his unconditional devotion while she communicated by literally kicking him. He looked after the child while she prostituted herself. Eduwa weighed 107 kg, was over 1.9 metres tall and had a body that could

bend metal. Nevertheless, he would huddle by the bed, forced into the foetal position as the frequently drunk Lujza kicked him as violently as she could. The following morning, his neighbours would see the same person as always, with a smile on his face and his head lowered as if he were embarrassed but happy. Every day he would pick flowers from the garden and place them at the foot of Lujza's bed, along with a jug of fresh water, honey, milk and one or two pieces of fruit. He would kneel down and watch her sleep, smiling and blessing life. He was grateful to his obscure gods for the happiness permitted to him and held on to that sensation as his greatest and only treasure.

"Two years later, Eduwa's patroness died and left him some money. Lujza took his small inheritance and ran off. Nothing was ever heard of her again. Eduwa faced her disappearance as if it were business as usual. She had disappeared in the same mysterious way she had appeared. He felt the same in relation to the money. He had an allotment that gave him a degree of self-sufficiency. He would beg if he needed more. After the death of his patroness he continued to live in the same shack as before. After its owner's death the main house, an immense building with a neoclassical design, ended up being abandoned due to family disputes and litigation. The inheritors didn't see eye to eye and the house began to deteriorate. Neither heir ever set foot there. They both lived in France, surrounded by their own fortunes, and had not the least interest in

that property, other than the possibility of one day earning some money from the sale of the land once the legal disputes were over. The whole time the house was wasting away Eduwa never once thought of inhabiting it. He stayed in his shack, watching a beautiful house decay, though not without some sadness."

"What about the child?"

"As I have already said, Mathias Popa was educated by Eduwa. Eduwa made a superhuman effort to ensure that Popa never went without food (even if he sometimes had to give up his own food) or education (though it was somewhat *sui generis* and not at all canonical). The boy grew, instinctively acquiring the same contempt his mother and almost everyone else felt towards Eduwa. Without being a bad sort, he did things that could easily be called obscene. Suffice to say that often, whenever he arrived home to find the house empty, he would eat whatever there was and throw out what was left, meaning that Eduwa would not eat. If you were to ask him why he did this, he would not know how to answer. Some people, like Eduwa, simply attract this kind of behaviour."

"And Eduwa did nothing to fight back against his situation?"

"He found it normal. He had always been treated like that, so none of it was new to him. He always kept a smile on his face and his head slightly lowered. He blessed life and everything he possessed."

"But he had no possessions, Mr Tóth. Or am I mistaken?"

"For some people, there is no possession more valuable than this."

"Than what?"

"Nothing."

Marlov rolled his eyes.

"Be that as it may," Tóth went on, "in time the boy learned to beat his father, just as his mother once had. Then one day he walked out of the house without a second glance. Eduwa died alone, poor and smiling."

"When was that?"

"Soon after the war ended. But before that he had the misfortune of being taken to Mauthausen concentration camp. He was there for two years. Please, Mr Marlov, take this sheet of paper."

"What for?" he asked as he took the sheet.

"Fold it."

Marlov obeyed.

"Fold it again. And again. And again."

Marlov folded the sheet until he could no longer fold it.

"You can't fold it more than four times, can you, Mr Marlov? No sheet of paper, regardless of its density, can be folded more than four times. Something as fragile as a piece of paper will not let itself be folded, and yet . . . a Nigerian giant could be folded countless times. That was what happened to him throughout his life, but in

Mauthausen he suffered even more than he was used to. In spite of that, he left there with something resembling a smile on his face. Eduwa was a sheet of paper that could be folded infinitely."

Marlov felt he could see Samuel Tóth's eyes going out of focus. Tears, perhaps.

"Now you will see just how many coincidences there are in this life," Tóth continued. "One day Hans Schafer was being beaten up outside a bar, a dive where he used to go to lie on top of prostitutes. This man had been a guard at Mauthausen. He was an odious sort, a subject quite deserving of all the hatred one has to offer. Eduwa recognised him immediately. Nobody ever forgets someone who has tortured them in the worst ways imaginable. Hans was being kicked with far less malice than that which he possessed inside his own battered body. Nevertheless, Eduwa didn't think twice: he threw himself against the man's aggressors, and with extraordinary calm sent two of them flying into a wall. The other four just ran away. Hans Schafer was in a very bad state. He had a few broken ribs and a broken arm. Eduwa carried him on his shoulders to the shack that he had built on the outskirts of Dresden. For months, he split what little he had with his tormentor. Although he had nothing, he worked every day: he was a beggar. Many people believe begging isn't work, but the truth is that begging is far harder work than working. Kneeling down is very tiring, and humiliating yourself

even more so. Nothing is more tiring than beseeching and imploring people to ensure your survival. But that was how Eduwa sustained himself, through begging and a few random jobs. Everything he earned was to pay for food for two people: his and that of his torturer. It is not in the least bit surprising, dear Marlov, that one day, once he had convalesced, Hans Schafer became his old self again: the moment he was strong enough to kick, he did just that. With his delicate smile and his lowered head, Eduwa fell to the floor and did not fight back. The other man stayed in the house for months. He beat him frequently and kept all the money he had begged. Eduwa never abandoned his shack or the duty of feeding his torturer. Every day he would appear with some coins in his hands before the other man made him sleep outdoors."

"Did he die?"

"Not then. Anasztázia Varga took care of him."

"Another of Zsigmond's daughters?"

"Exactly. The youngest of all his legitimate offspring. She was born just after Lujza was expelled from the home. Her birth came at the expense of her mother's life. She was raised by servants and had no relationship with her siblings at all. She was a sweet person, completely different from either of her parents, a beautiful, generous, innocent young girl, a fairy-tale character who had not in any way adapted to a world of war. One day, by chance – by now I'm sure you understand how things operate in

this world – she met Eduwa on the street, sick and near death, and took him to the Varga house. Once he had recovered, Eduwa worked as a gardener at that mansion for nearly two years. Anasztázia was especially affectionate towards him. When Varga discovered her fondness for him, he made his daughter get rid of Eduwa. She obeyed, but still found him somewhere to live where she visited him regularly, bringing him food and money. Eduwa died of pneumonia during a particularly harsh winter. Anasztázia was at his bedside when it happened, in what would become perhaps the most important moment of her life.

"Perhaps you will find it hard to digest some of these coincidences, but life is a complex tangle of threads. Either we do not see the majority of them, or else we are unable to tie up the knots of the relationships between them. But everything touches everything else, all events are connected to each other by these lines. What I am doing, in telling this story, is emphasising the ones which I can clearly see and perceive to be of relevance. I let countless others which I don't consider significant remain invisible, along with many more with which I cannot manage to establish a link. That is why the stories we tell, life stories, seem like great miracles of fate: because we wipe away that which is of no interest, that which tells us nothing, in order to reveal only what is essential. Note that I do not just speak of great events, I also relate small details, and yet I recognise the importance and significance of every

one of them. But as I was saying, Eduwa was dying and so he did what Socrates did. Did you know that before he died Socrates said that he owed a cockerel to the gods? To Aesculapius? Well, Eduwa did the same thing, and Anasztázia felt obliged to honour the promise she made. She boarded a plane and landed in the French Sudan. She went overland to Nigeria, passing through Dahomey after crossing Upper Volta, modern-day Burkina Faso. Journeys at the time were not done the way they are nowadays, especially when we are talking about a woman travelling alone."

"She travelled to Africa to sacrifice a cock?"

"Not a cock necessarily. The goddess Oshun prefers other things. Anasztázia travelled across Africa to give some sweets to a goddess called Oshun."

"She travelled thousands of kilometres just to put some sweets on a shrine?"

"Yes. I recognise it was rather a bold decision for the time, but that is what happened, I'm not making anything up. To continue, on her way back from Nigeria, Anasztázia met a man with whom she fell in love."

"What was that man's name?"

"It is not yet time to say his name."

CHAPTER 28657

"It was a love affair straight out of the eighteenth or nineteenth century. With all the fiery passion that implies but with all the underlying Greek tragedy as well. One day, the two of them were in bed and Anasztázia asked him why he was there. Note that despite screwing like wild animals for days, they still had not conversed much beyond basic details like each other's names. Because of this, when he asked her about her life and what she was doing there, she told him about how she had met Eduwa and how he, on his deathbed, had asked her to pay a debt to the gods: it was necessary to give an offering of sweets to the goddess Oshun. At worst, to sacrifice a cock to some other god, to Shango perhaps."

"And?" Marlov asked.

"And now I will tell you the man's name: Mathias Popa. The exact same name as Lujza Varga's son. The reason behind this coincidence is very simple. He was the same person."

"Wasn't there a considerable age gap?"

"No. Actually, Anasztázia was two years younger than Mathias Popa."

"In other words, Anasztázia was in love with her nephew. She was sleeping with him."

"Exactly. When Popa heard about the gardener, he asked Anasztázia her surname. They had been intimately intimate and yet they had not revealed their surnames to each other. When Anasztázia said the word 'Varga', Popa got out of the bed like an automaton and left without saying a word. She never saw him again."

Samuel Tóth took a few steps to one side and invited Filip Marlov to follow him. In an adjoining room there hung countless works of art and photographs. Not just on the walls but also in the middle of the room, like a washing line. An immense staircase rose up from the centre, connecting all seven floors.

"We manufacture lives here. We don't make fictions, we make reality. We multiply Man, we create new ways of seeing things. We transform characters into historical figures. St Paul managed to transform a man into God. He had a raw material, a subject, who had nothing to do with the final product, which was refined over the course of many years and several councils. And that is what elevates a man to immortality: his ideas become universal and inseminate all of us. Words can enter into the ears of inconceivable, uncountable numbers of people. It is by

becoming many that we end up being everybody, the All that is the One. Man must be seen from several angles at once, superimposed. A single man must be full of incoherencies and anachronisms and be able to live with it. We must put ourselves in the positions of others, fill ourselves up with other people, the enemies, the friends, the thieves, the whores, the ministers, the taxi drivers, the engineers, the impostors, the generous, the wild, the liars, the dastardly, the wretched, the Buddhists, the bankers, the anarchists, the aeroplane pilots, the pigs, the saints, the Christians, the neighbours, the mad, the abominable, everyone, everyone without exception, including relatives close and distant. All of them inside us so that it is easier for us to understand those differences and, eventually, find some peace in the midst of all that tension. Wars struggle to exist when people understand one another. Fewer bombs fall, buildings tend to stay upright, bodies do not shatter with the same frequency, limbs stop flying about; perhaps even cages will cease to exist and concentration camps will become museums for our memory. As I have already said, we manufacture lives here. We take characters off the paper, characters as fragile as the pages they live on, and give them existence. Ideally, we would have characters made of earth, but for that we need to make them live among men, go shopping, exhibit their creations, share their thoughts, be quoted, talked about. Listen, Mr Marlov, existence is made up of testimonies.

Without them, there is nothing. We exist because of the 'other'. Without perception, there is nothing. *Esse est percipi*, Berkeley said, and rightly so: to be is to be perceived. We exist because there are testimonies, because there are mirrors all over the Universe. Our relationships with the 'other' create us. There is no noise if there is nobody around to hear it. There's an old, anonymous fragment from the first century After Hijra, which says that the sky became apparent only once God had created birds. It was there in principle, but no-one was perceiving it. In short, what we do is exactly what Oscar Kokoschka did: we take our fictions out to the opera."

"And Mathias Popa?"

"I met Mathias Popa when I bought this house. This business of taking characters out to the opera was born from his story. I tried to contact Anasztázia Varga at one stage. I sent her a postcard but received no reply."

"Can I speak to him?"

"That would be difficult: Mathias Popa died several years ago. Something in his head."

Tóth pointed to his own head with his right index finger before continuing:

"The Mathias Popa whom Anasztázia remembers is a much better, far more defined person than the other Mathias Popa, who spent his time in brothels, playing card games and drinking. Anasztázia's Mathias Popa was built out of love. Even though love is a mere biochemical

product produced by glands and other viscera. In a broad sense, as Empedocles taught, love is the force that binds the Universe together. But the Universe is made of hatred, of corruption, of things that set people apart from each other. Entropy. If you were to gather together sand and salt you would never expect to make a window from them, not in a million years. But if you had a window, it could very easily be transformed into sand. You need only leave it outside and let the inorganic part of nature play its part. Destruction is apparent in everything that surrounds us. It is an easy process. What's hard is construction. We are surrounded by hatred and death: the Universe is a predator. Life is one of the only things that combats this entropy. It joins together cells and organisms and creates cities, communities, clusters. Everything else falls apart. We living beings fight with all our might against the hatred around us, but it is the Dresden of 1945 which prevails. All it took was a moment of hatred for the city to fall, to crumble into ashes. One moment of love will not put it back up again, for that an immense effort is needed. Hence we fight against the greatest force in the cosmos, against its characterising feature, against what it does best: expansion. The Universe is expanding, even during moments of leisure. What that means is that it separates everything, it makes all things move further away from each other, dissolve. Love continues to put the pieces back together where possible – like an old-age pensioner playing

dominoes – and the Universe comes and scrambles it all up again. Expanding, spreading out, like a clumsy giant destroying everything in its wake: birds, solar systems, windows. We need to remind ourselves that life is a phenomenon which comes from love, from union, among all the pieces of which it is made."

"So Mathias Popa is dead. Something in his head, did you say?"

"Precisely, Mr Marlov, precisely."

CHAPTER INFINITY

THE LAST

Filip Marlov rang Adele and told her the results of his investigation abruptly and in as few words as possible:

"Mathias Popa is dead," the detective said. "Something in his head. To top it off, he was your grandmother's nephew. I return to Paris tomorrow."

The following night, Adele met Marlov to hear the story in more detail. Despite his ability to decorate and narrate details with a great level of fussiness regarding atmosphere, gestures and facial expressions, the detective was completely incapable of understanding how things were woven together. He described Tóth's dress and the way he moved. He described the house that Imre Lakatos had designed down to the last detail. Because he passed over anything of an abstract nature, Adele had to imagine everything missing from Filip Marlov's two-dimensional narrative. She heard the intricate story of her great-grandfather,

who sought to weigh Evil and collected butterflies. She was astonished when she glimpsed that invisible thread which unites every destiny or, if you like, every tragedy. Her grandmother would have to be content with her memories, her past, with those balls and chains, our heads, that we drag throughout our lives.

Adele Varga left Filip Marlov's office feeling a sense of rage. She did not know who to direct it against, but she felt hurt by the way the Universe treats our precious feelings. She entered the nearest bar and ordered a Manhattan. At that moment, while she was drinking, a man appeared next to her. They talked about music and at the end of the night they fell in love for ever. And they stayed that way, in this most unnatural state, for the rest of their eternity: fighting against the Universe. In the background, a piece by Django Reinhardt was playing: "Tears".

The painter Oscar Kokoschka was so deeply in love with Alma Mahler that when their relationship ended he commissioned a doll of his lover to be made, life-size and accurate down to the last detail. He sent a letter and several designs to the puppet maker detailing how it should be made, including the folds of her skin he considered indispensable. Far from hiding his love, Kokoschka took the doll for walks in the city and out to the opera. But one day he tired of it, smashed a bottle of red wine over its head and threw the doll into the rubbish. It was then that the doll became a fundamental part of the destiny of several people, survivors of the four thousand tonnes of bombs that fell on Dresden during the Second World War.

Part Three

Miro Korda (Minor Swing)

He entered the hall. People were clustered together, mostly around tables. There was lots of tapas and seafood and no shortage of drinks. In the corner, a slight Japanese woman, draped in a very light-green dress, was sitting at one of the tables. She was swinging her legs like a girl. That's the kind of movement that makes women lighter, younger, Miro Korda thought. The Japanese woman must have been some forty years old and was holding a baby duckling in her hands. Korda walked past her and nodded in greeting. The woman showed him the duckling and Korda stroked its head awkwardly with his enormous hands. The duckling quacked and the woman laughed.

"Do you like my green dress?"

"I do. It will be even better once it ripens. Is the duck yours?"

She did not reply. Her eyes were lost in the distance as she gazed at the duck.

"Are you playing tonight?"

"I am."

"When?"

"When I finish my beer. Why?"

"No reason. I think the duck's getting impatient. Do you want to give his head another stroke?"

Miro Korda raised his right hand and passed his index finger under the duck's bill. In the Japanese woman's tiny hands, the creature fanned its wings and opened its bill. It seemed to be shaking off some water. Korda dipped his finger in his beer and put it in front of the duck's bill.

"What are you doing? Are you stupid?"

Korda did not reply. He gestured with his (enormous) hands and went onto the stage. He took off his jacket and hung it on the back of the chair. He never played without a jacket hanging off the back of his chair. He adjusted the ashtray (which he was always knocking over) so that it wouldn't fall and took a cigarette from the packet. He lit it and fastened it between the guitar strings, by the machine heads. Once the guitar was tuned, he played some scales to wake up his thick fingers.

I'll never be a great guitarist, Miro Korda thought as he looked at his hands. They're too big and unrefined. I struggle to reach some frets and my fingers aren't fast enough. My right-hand fingering is clumsy too; sometimes I play more than one string by accident.

Korda placed the guitar in its stand, took his beer, knocking over the ashtray as he did so, and headed to the bar.

He closed his performance with a version of "Minor Swing". His honey-brown guitar perfectly complemented the dark pinstripe suit he usually wore. He always performed in dark glasses and a white shirt. He left with the Japanese woman in the green dress and they went to her house.

Korda was an impeccable dresser with very big knuckles. They looked like potatoes. His nails were pink and always very well looked after. He tried to walk at the same pace as others, the Japanese woman in this case, but it was difficult because her legs were so small. At times she had to hop to keep up with others, though she always did it discreetly.

Anamnesis

"He had an operation to treat an aneurysm," Korda said, a cigarette in his mouth. The Japanese woman listened to him most attentively as she twirled up the dress in her hands. "He forgot everything. Everything! He couldn't even play a C. And he was a musical genius! He had to learn to play the guitar again. From scratch. He's living proof that Platonic anamnesis is a fact. He learned to play again by listening to himself. He played his own records and tried to imitate himself. He managed to become a great guitarist once more.

"That's why I like Plato: the thing about our soul having been in contact with Ideas, and how we forget everything when we get here, to Tercena station in Lisbon. That's when life, which is really little more than trying to recall that world of ideas, begins. Just like Pat Martino. I never played with him, but I'd like to ask him a few things."

"I've never heard of him. So this Pat Martino had an aneurysm?"

"And then he forgot everything. He had to learn to play by listening to his own recordings. Go into a record shop and look in the jazz section. Pat Martino. Remember the name."

She opened the door from the street and went up the stairs. Miro Korda grabbed her waist and she swayed her non-existent hip bones back and forth. They entered the apartment.

"I'll put the duck in its box."

There was a cardboard box lying on top of a desk. The apartment was impeccably tidy and had so little furniture that it was like a zen garden, stripped of so many roses and gladioli. The television was on the floor and there was a chair by the desk. The duck quacked as Korda, with his very big hands, held the Japanese woman's slight body. In his head, he was singing to himself: *The duck was dancing by the water, quack quack, the rhythm made him think he oughta, quack quack, he was dancing to the samba, the samba, the samba.*

Korda used chords to classify people

Korda used chords to classify people. He would walk down the street and attribute chords to passers-by. He did the same with friends, family, acquaintances, and sometimes objects too.

A pessimist is a minor chord.

A sophisticated woman is a ninth.

A teenage girl in a skimpy dress is a sixth.

If she retains her sense of fun beyond thirty, she is a thirteenth.

Bearded philosophers are diminished sevenths. Sometimes they are single notes.

clack-clack-clack

He got on the train carrying a newspaper under his arm. He leaned back against the pole and read the headlines. Occasionally he got distracted when a pair of women's shoes entered his field of vision. When that happened he would look up to see the face and assign a chord to it. Whenever he met anyone, he saw a musical structure and a composition. When he was speaking to people he knew he could feel their corresponding melody playing right by their temples. It was a subtle yet concrete sensation, a hive of sound.

There were no shoes that day, so he read the paper – just the headlines – from cover to cover. He got off at Baixa, leaving the newspaper behind. He combed his eyebrows with his thumbs in a cakeshop display case. He went down Rua Garrett, his heels resounding on the pavement: clack-clack-clack.

Death is one of those machines for reading barcodes in supermarkets and so on

Night had already become day as Miro Korda polished off yet another whisky. He stood up, took a few short and clumsy footsteps, and leaned against a wall. He put his guitar down and smoothed his hands over his face to comb his eyebrows, then took the packet of cigarettes from his pocket. He lit a cigarette slowly and drunkenly and filled his lungs as he gazed up at the cloudy sky. At that moment he felt as if he were filling his lungs with clouds. It looked like it was going to rain.

Bairro Alto was almost deserted by that time, and the people still walking past did not look as if they wanted to make friends. Korda was not afraid. With his 1920s moustache, which was showing a few white hairs that were just as neatly combed as the others, he watched the passers-by with the lack of focus of someone who is not afraid and/or is very drunk. With his thick hands he could twist an iron bar until it begged for mercy. He had an aquiline

nose, blue eyes and a bespoke pinstripe flannel suit, which fitted him perfectly. He stubbed out his cigarette using his heel (a heel too big for Humanity, let alone one man) and picked up his guitar to go home. Miro Korda was not tall, something he deeply resented. He was a man who always made sure that the heels on his shoes gave him the height he lacked in his soul. It was ever thus: what we lack on the outside is merely a reflection of what we lack on the inside. Or vice versa. The reason he had big heels, he claimed, was so that he could dance the tango, a dance at which he had proven himself to be completely inept. One time, after playing for an hour and a half in a Buenos Aires nightclub, he had spotted a scrawny old man with enormous heels dancing with a colossally breasted hooker. He stared at the couple so much that the woman, believing she knew the reason behind his interest, went over and sat at Korda's table. Without hesitating, she put her hand on his groin and ordered two drinks. One for her and one for Korda. Her lips, smudged from so many nights of dancing the tango, made a brief journey to Korda's desolate lips.

"I'm Mercedes."

"Miro."

They danced a few numbers until a man jumped up and grabbed the microphone to announce that the future was guaranteed with the hip hop they would soon be hearing. It was not guaranteed, Korda could guarantee that,

but it meant he could rest for a while from the tango and from his companion's hands.

"Where are you from?"

"Portugal."

"I'm an English teacher. I teach at a private school. I come here at night to dance – dance is everything in this life – and to enjoy myself. It also helps pay the bills at the end of each month. But I won't sleep with just anyone. Basically, I combine utility with enjoyment. Is that a Portuguese name?"

"It's my stage name. My Christian name is Ramiro Corda."

"I understand. I also use the name Mercedes, but it's not my real name."

"What is it, then?"

"My real name?"

"Yes."

"I still don't know, although I do feel that our Christian names, the ones we are given at birth, aren't our real names. Do you understand me? There is another name, hidden beneath our wrinkles, beneath all of our misfortune, which is our barcode, like when you go shopping. One day, when I'm dying, when death is in my eyes, I'll know what that name is. Our last sigh is just that, Miro, our true name. Of course, no-one understands it. It's very difficult to translate a sigh into a whole person, into an infinite soul. But that's what that sigh is, an eternal name,

a stage name, as you put it. Death is like one of those machines for reading barcodes in supermarkets and so on."

"Miro is what my parents called me as a child. I kept it like that, because I was disappointed by the first two letters. Then I swapped the C in the surname for a K, for purely aesthetic reasons. I know nothing about this last sigh, and I'm still too young to find out."

He tried not to prolong the conversation, but she had a long tongue, full of questions and answers.

Job.

Age.

Height.

Religion.

Star sign, lunar and ascending.

Political leanings – (here she said that the only right worth taking seriously is the one you take after turning left twice). Korda didn't understand. She sketched it on a napkin.

A big lie, is what we are

"You're not much of a talker," she said.

"Sometimes I'm like a parrot. I talk a lot. A friend of mine who plays saxophone, though not very well, is always telling me to shut up. He says I talk a lot."

Korda woke up in a guesthouse in the centre, with that enormous woman and an equally large hangover. But he still had a vivid memory of that tiny old bald fellow with the big heels. He had been dressed impeccably and had danced as if Gardel were his shadow. Korda asked Mercedes who the old man was:

"Who was that man you were dancing with yesterday?"

"Filetas. He can't dance, but he has good posture. That's essential. Some men hold me as if I were a delicate piece of clothing, with fancy labels. Filetas knows how to hold a woman."

As she said that, Mercedes grabbed her thigh with a look of extreme concentration. Her cheeks trembled and

her white face turned red. Then she grabbed her breasts and did the same thing.

"This," she pointed to her body. "It's as if I were a bull," she said. "You've got to do it with attitude. Filetas is so light that any woman could make him levitate using just the smoke from a cigarette, but he compensates for that with a good pair of heels, dominant hands (like yours) and his attitude. There is nothing as heavy as a good attitude. The heels simply bring that out."

Korda nodded in agreement.

"You've got to have attitude," she said, "so that you don't take flight, so that you have roots even when your feet are moving with the grace of the tango. A man must always have his feet firmly planted on the ground, even when he is jumping into the abyss. A great deal of seriousness is needed. Lightness is no good to any woman. Dancing the tango looks like something light, but that is nonsense. I've seen people dancing with smiles on their faces. They have nothing to do with tango. They're circus artists who have simply memorised routines. There's nothing more serious than this dance. I lost many relatives before I could dance the way I do. Many funerals, many misfortunes, and then, in the midst of all that tragedy, tango appeared. But it's not a happy thing. It's serious."

"A man must always have his feet firmly planted on the ground, even when he is jumping into the abyss," Korda repeated thoughtfully. "Men never laugh when they're

fucking. I've heard it said that you can't have children in space because there's no gravity. There's no seriousness. There's nothing funny about sex. That's why we make pained faces. We don't laugh."

"Our lives depend on the lightness we give to our weight, and vice versa."

"And vice versa," Korda said. "Men partake in one of their greatest pleasures with a look of suffering on their faces. Clearly, we are a big contradiction."

"A big lie, is what we are."

I'm a non-practising atheist

"I'm going to Paris tomorrow."

"You're abandoning me."

"No, father. I'm going there to play."

Emílio Corda was looking at a dejected mug, with no coffee in it. Miro Korda was doing the same.

"Life is fucked," his father said. "The other day I was in a restaurant and I understood the whole Hell and Heaven thing. It's very simple. Imagine a group of people enjoying themselves in a restaurant. The food tastes good, they're all talking to each other, the wine is flowing. In short, they're all happy. On another table there is a group of people looking at each other with hate in their eyes, hiding smiles, saying yes when they mean no, attacking each other, stealing and throwing food. Complaining about the food's quality. Do you see the problem? The restaurant is the same, the chef is the same, the menu is the same, but some people are enjoying themselves and others aren't. Heaven and Hell are the same restaurant. The only

difference is the people sitting next to you, at your table. When are you back from Paris?"

"What you said about the restaurant means nothing to me. I'll be back in a week."

"What I said about the restaurant means nothing to you because you are an atheist. You eat omelettes, but don't believe in chickens."

"Actually, father, I'm a non-practising atheist."

"But there's a third table in that restaurant. A lonely father is sitting there, dining with no-one else around him."

"I'll be back in a week."

"A lonely father, that's who's sitting there."

Miro Korda takes a bow

Miro Korda packed his bags and caught an aeroplane. He sat down abruptly (or perhaps the space was so tiny it just looked as if he had sat down abruptly) and opened a bottle of Polish vodka he had bought in Duty Free. He drank two or three glasses, with no ice and no hesitation, along with one pill for sleeping and another one for sickness. He looked at the hostesses' bodies and pretended to pay attention to their instructions: the emergency door, the masks, the arm signals, the lights along the floor, the life jackets. He put his seat back just so that he could be reprimanded by them (put your seat up, one of them said, and he smiled a roguish smile).

He fell asleep instantly, before the plane had even taken off. He woke up a few times to allow other passengers to go to the bathroom and to finish off the bottle of Polish vodka. When the plane landed some of the passengers clapped; Korda got up, still only half awake (he had been in a deep sleep), and took a bow, grateful

for the applause. He fell into his seat, number 14G, and went straight back to sleep. It took two hostesses to wake him.

Miro Korda in Paris

He looked for a hotel, but all he found was a guesthouse. It was snowing.

Assault

Korda walked a few metres, holding his guitar, before hearing some shouts. It was five in the morning. The shouts were coming from a side street. Korda stopped, almost staggering, and looked to his left. Once he had managed to focus, he saw a girl being assaulted by two men. He crossed the street with his guitar and – once he was right next to the girl, who was clutching on to one of the straps of her bag while one of the men grabbed the other – placed it down very carefully. A second attacker was trying to pull the girl's arms, but she was quite capable of defending herself. It was not an easy assault. The woman was captivatingly agile and had loose, black hair, almost as flexible as her long legs. She was slim, without being very tall, and had a small mark by her left eye. She was firing off violent kicks which the men struggled to parry.

The attackers stopped when they saw Miro Korda, trying to understand what the meddler with the anachronistic moustache wanted. Korda did not say a word. He

cut through what they were saying with a blow that landed straight on the man nearest to him. The violence of the impact was so great and the noise so incredible that the other man ran off. Korda looked all around him but could only see the attacker lying on the ground. The woman had escaped when he had walked over.

This seemed like the right moment to vomit, which was just what he did. He took out a tissue to wipe his mouth, smoothed his hands over his eyebrows and thumbed his moustache. He picked up the guitar and went to the guesthouse.

The thunderstorm woke him in the middle of the night. His heart was pounding and he was gasping for air. He went to the mini-bar and poured himself an orange juice. He lit a cigarette and leaned against the window. At intervals, the flashing of the lightning illuminated the city of lights. Korda began to feel cold and went to lie down. He felt strangely agitated and took a while to get to sleep.

He woke up with a bad headache and took an aspirin. He combed his eyebrows with his thumbs and went to have breakfast: several glasses of juice and bread with cheese and jam.

After a week of meetings, he got a taxi to the airport and went back to Lisbon.

Thumping the walls

The sound of the football commentary was coming through the walls. Emílio Corda beat the plaster with his fists and shouted at whoever it was to turn down the radio. The volume went up. Muffled shouts mixed with goals, fouls in the area and corners to be marked. One of the yellow cards was particularly loud.

Korda was listening to an album with the following songs on it:

"Fly me to the moon", "I've got my love to keep me warm", "Minor swing", "Weed smoker's dream", "Caravan", "Lazy bones", "My funny valentine", "Stardust", "You belong to me", "Brother can you spare a dime?", "Moanin' low", "Primitive man", "Sway", "Strange fruit", "Forgotten man". When it had finished, he listened to the same songs again: "Fly me to the moon", "I've got my love to keep me warm", "Minor swing", "Weed smoker's dream", "Caravan", "Lazy bones", "My funny valentine", "Stardust", "You belong to me", "Brother can you spare a dime?",

"Moanin' low", "Primitive man", "Sway", "Strange fruit", "Forgotten man".

His father continued thumping his fists on the walls.

In my day it was called a gullet

"How are you?" Miro asked.

"I don't believe a word of what they're saying," his father replied, folding the newspaper and placing it on the kitchen table.

"I was talking about the hangover, but what are they saying?"

"That Man comes from apes. It might be the case for some people, but not all of us. Decent people still exist, there's no need to be so pessimistic. It's not the priests so much as the monkeys who have been wronged by this theory of the evolution of species. They don't deserve it. Yesterday I went to the doctor, and when I left I bought two bottles of brandy. I drank one for my back and another for the world. The doctor told me to open my throat, and I said, in my day it was called a gullet. And then he stuck that silly little stick down my throat (which used to be called a gullet) while I said *ahhhh*. That ice lolly stick of theirs is an instrument of torture. Where's NATO when

you need it? And the prostate examination, Miro, do you have any idea how humiliating it is? It's medieval. It's enough to make a fellow cry out for the bonfire. I'll tell you everything, I said, but still the doctor kept his fingers rammed up my arse. I confess, I was shouting. Yesterday they stuck a skewer in me, the kind you'd use for a barbecue. As thick as my little finger. I was red raw for a week. I could only sit down with the help of a prescription drug."

"Wasn't that yesterday?"

"Exactly. I was red raw for a week. Besides, they're the ones who made off with half of my liver. I only have half an organ. Doctors are a bunch of thieves. They don't cure, they invented surgery to steal things from us. When there's an illness, they extract things. That's not curing, it's stealing. We get smaller and smaller while they get richer and richer. There's no shortage of illnesses for them to fill their pockets with. Humanity has more illnesses than people have humanity. And this is the state of affairs. The doctors get their fill and we end up with no organs. That's one way to keep track of our decay: how many organs are you missing?"

"What about the hangover?"

"Pamplona died."

Emílio Corda scratched the blue veins on his nose.

"When was that?" Miro asked.

"When his heart stopped working, the lazy thing. The night before last. I received a telephone call from his wife."

"When is the funeral?"

"I don't plan on going."

"Why not? He was your best friend."

"He was nothing of the sort. The other day I went to his house and found two videotapes."

"And?"

"He never even had enough money to buy spinach to put in his soup. He didn't even have a television."

"Maybe they weren't his."

"They were. When I noticed them on a table in the living room, he started stuttering and saying they weren't his."

"He wasn't telling the truth?"

"I looked at the tapes. They were black-and-white classics, you know the kind. Films we'd watched together in the fifties, when I used to pay for his cinema tickets, since he didn't even have enough to buy spinach to put in his soup. He would show up at our house and my mother (your grandmother) would feed him. He was skin and bones. I paid for his cinema tickets. A month back, I went to his house and saw them lying on his coffee table. I listened to the explanation he came up with: they belonged to a friend, but I know him, or rather, I knew him, and I felt he was hiding something. This morning, his wife told me everything. She couldn't keep it in anymore. As you know, Pamplona and I used to play the lottery, and we did it every week for the last thirty years, no exceptions.

I never checked; he took care of everything. Whenever we won any money we'd invest it in the following week's draw or spend it on a seafood dinner in Alcântara. But twenty years ago, the bastard won the top prize. Millions of escudos. He said nothing, hid everything from me. On the one hand, he didn't want to share the dosh, on the other hand, he didn't want to lose me as a friend. So he continued to live like a pauper and only ate well when I wasn't looking. He even bought a television, then later a video player to watch black-and-white movies on. Detective films and the like. The ones we used to love, with Bogart and Lauren Bacall and scripts written by Chandler! Once I offered Pamplona a raincoat just like the one Bogart wore in 'The Big Sleep'. Our friendship lasted fifty years and for the last twenty or so, whenever I went to his house, he would hide everything in the room in a box underneath the bed: the television, the video recorder, a food processor and a painting by some Impressionist or other. What a stupid life. His wife couldn't bear the situation any longer. Thousands in the bank and yet she was unable to spend as she'd have liked to because Pamplona wouldn't let her. If she wanted to buy a dress, he wouldn't let her. Or she would buy one and had to wear it only when she was with her family, where I wouldn't be able to see it. More than twenty years of this. Now Pamplona is dead and she has all the money. She told me everything and won't give me anything. Even though I paid for half of that

lottery ticket. I told her to shove it up her arse and that if she ever did happen to have the honesty to do the honest thing and give me my fair share, give me what was mine by rights, I'd give it all to the poor, because I want nothing from them. Decades living like a pair of beggars, just so they didn't have to share the money."

"You're not going to the funeral?"

"Didn't you hear what I just told you? About the video-tapes and the black-and-white films?"

The next day: the whole night

The next day, Korda played the whole night, far longer than he'd been paid to play for.

Have you ever noticed that this is all raw material?

It was a foggy morning and Miro Korda walked lethargic-
ally through the damp air. His impeccably combed hair
was pushed slightly back as he moved. His heels beat
down on the pavement, making a clic-clic that was simi-
lar to rain beating down onto a window. Magro's café was
right on the corner, and that was where Korda would have
his ritual breakfast, which consisted of brandy, two ciga-
rettes and something savoury, usually a croquette.

As he entered, Magro heard the sound of Miro Korda's
heels and began preparing his breakfast. He carefully
poured the liquor, made the coffee and advised him on the
savoury options:

"The rissoles are wonderful today, a quintessence of
seaweed with a puree that's absolutely perfect. More than
ten thousand years of civilisation have culminated in the
delicacy which we humbly call the rissole. Will you be hav-
ing one? Or would you prefer to wound my good taste by
opting for a merendinha? They're also good."

"Good morning, Magro. Maybe I'll have a croquette."

"Good choice, I couldn't have chosen better myself. You have bags under your eyes, Korda. Rough night?"

"Not exactly. A diminished D, completely out of time, but thank God the audience is deaf to such things. Some months ago I witnessed a woman being attacked. I can't get the attack out of my head. I can't remember her face, but I dreamed about the scene just yesterday."

"There are many dangers in this world."

"I help her," Korda said, displaying his fist, "and she runs off without saying thank you."

"There are no manners in this world. Have you noticed that this is all raw material? How can a refined spirit be born from something as crude as all the raw material of this world? We behold the twists and turns those intestines which we call brains make inside our craniums and cannot understand how that stuff, all of it so grey, can have any ideas at all, much less any courtesy. Here's your coffee."

Deep in thought, Korda drank his coffee while Magro put the dishes in the machine. He took out a cigarette and lit it. He asked for the paper so that he could read the sports pages.

"Anything else, Korda? A rissole?"

Miro Korda paid and left. He walked for a while, entered a bookshop, bought two books and returned home. He stretched out on the sofa together with a lit cigarette,

an ashtray and a book by Heinlein. After an hour he fell asleep and woke half an hour later, feeling a little on edge. He took off his suit, set the alarm clock for 5 p.m. and, after taking a painkiller, lay down on the bed. He fell asleep again.

My life is a desert, if I stop drinking I'll dehydrate

Korda woke up before the alarm went off. His father was bending over him, out of focus, his nose bursting with blue and red veins. Korda's hands, which were anything but Euclidian, grabbed his father by the shoulders and pushed him away. His father, Emílio Corda, slid down the wall and settled on the ground. Miro got up and leaned over him.

"Drunk again?"

"I haven't had a drop."

"You need to stop drinking."

"I can't. My life is a desert, if I stop drinking I'll dehydrate."

Korda grabbed him and helped him to lie down. It took half an hour by the time he'd changed his clothes. His father fell asleep.

Korda went to the kitchen to fry two eggs with some chilli. He ate from the fridge using a wooden spoon. He went to his bedroom, staggering slightly, and glanced briefly at his father, who was snoring on his back. Korda threw a blanket over him, which fell lifelessly onto his legs and the lower part of his body.

Reservation for one

Korda was playing all over the world and was away more and more frequently: Panama, cruise ships, Switzerland, Japan, France, the United States, funerals, Germany, Austria, Singapore, weddings, anniversary parties. While he was playing, his father was spending more and more time alone at a restaurant table. And so it would be for the rest of his life and, who knows, for the eternity of death too.

The real-life Adele Varga

NEITHER ONE POSSESSED THE PATIENCE
TO LOOK AFTER A CHILD

Of all the things that could be said about Adele Varga, the most obvious was the determined way in which she moved, so much so that even her more tender movements had a certain violence about them. She spent her childhood cut off from many things, brought up by her grandmother with no input from her mother and father. Neither one possessed the patience to look after a child; they were never close to her, most likely they were never close to anyone, not even themselves. Her father, a hugely successful lawyer, was a fickle man, always wanting to be where he was not, with thick bags under his eyes and a dazzling, open smile. He had blue eyes, which perfectly complemented his dark complexion. He always had stubble on his chin, uncombed hair and the knot of his tie loosened with a hint of carelessness so natural on him that

nobody noticed, not even during more solemn moments, that they were standing before what was essentially a wild beast with a law degree. Adele's mother was a thin, pretty woman, who spent a fortune on dressing herself, while men spent a fortune undressing her. There's nothing more to be said about her. She was completely absent from the home and completely present everywhere else.

There is more to family than grandmothers

As a young girl, Adele spent a lot of time alone playing with dolls (her father gave her lots of them, almost all blonde, almost all dark-skinned). She tried to bring them to life, dressing them and taking them for walks, taking them to the opera, bathing them and sleeping with them, proving in doing so that fiction, not a dog, is a man's best friend. It's also his first one. Unfortunately, it gets old rather quickly and tends to wrinkle as we ourselves age, eventually becoming a shadow or a lie.

That is how Man finds himself in abject poverty; rarely has it anything to do with the amount of money he has accumulated. Adele Varga's hours of loneliness brought her a unique way of being, some independence, and little patience for living with others. She liked people, of course, but she could avoid certain people with no sense of embarrassment, manners or propriety whatsoever. She was highly fixated on various arts, showing a clear preference for the martial kind. She practised several during her

adolescence, most of them Japanese. Her grandmother gave her all the attention she could, that was her nature, but even so she was not enough. Adele Varga was certain that there is more to family than grandmothers.

La Danse Macabre

Adele Varga's best friend during her teenage years was a prostitute called Paulette who gave discounts to customers with left-wing politics. She charged others the full amount. Once her everyday expenses were covered, she used the free market of her body to finance her personal war against capitalism. She printed communist propaganda posters and stuck them on walls.

Paulette was as thin as Adele Varga, but with a completely different outline. She had non-existent breasts, bony hips and big, flat feet. She lived with a man who was much older than her and who seemed to love her, despite showing a solemn indifference towards Paulette's nocturnal activities, both political and sexual. The old man whom Paulette called "old man" was an avid collector of death notices from newspaper obituary sections. He had everyone's obituaries, thousands of them, archived in countless folders occupying every shelf in his living room. The bedroom walls were also covered in these cuttings, the notices

with their photographs and black crosses, a grim parade of deaths from floor to ceiling. The dead in their hundreds, stuck up only with tape. The old man never spoke about this private *danse macabre*, his vast collection of the dead who were either imprisoned in sticky tape or carefully filed away, but because he had been an official in the Foreign Legion he was always talking about deserts, telling stories far darker than any of those newspaper clippings. He knew every snake, from the most poisonous to the most delicious, and told war stories so appalling they had to be true. Adele felt a strange, almost sensual pleasure as she listened to him talking about those battles. Paulette also loved listening to him; she would laugh out loud and sometimes she would take him into the bedroom to have sex surrounded by all the dead and their sticky tape. On one occasion, Adele joined them, and that was how her sexual life began.

One day, Paulette disappeared

One day, Paulette disappeared. Adele Varga looked for her in all the places her friend frequented, but to no avail. The old man didn't want to know and nor did the police. Whenever she went out at night, she would look at the walls in the hope that she might see one of the propaganda posters her friend liked to put up. In vain.

Plasmodium vivax

Adele Varga studied Economics just to give herself an academic motivation to find a job. She didn't get a job in her field, so she began working in bars, followed by more bars. She rented an apartment because she felt she needed some independence. Her grandmother did not like the life she was leading, but said nothing, that wasn't her way; on the contrary, her granddaughter always had lots of money to spend in her account.

One day, as she left work alone – on a side street off the Champs-Élysées – Adele was assaulted. When she arrived home she had injuries to her right thigh, right arm and back. Noting that she was lacking her customary resoluteness, the porter asked if she needed anything. Adele gave a faint smile, brushing back her hair to show a scratch on her cheek, and answered No, thank you. She went up in the lift instead of using the stairs, as she would have done on any other occasion that had not been preceded by an attack. She entered her apartment, put down her bag and

opened the fridge. She grabbed a mineral water and drank it as she walked to her bedroom. She stopped in front of the mirror: the scratch on her face had been caused by the bag strap as they tried to pull it away from her. She took off her jumper and looked at her back, contorting her body as much as she could. There was a black mark next to her tattoo of a Japanese flower. Her right leg hurt because she had knocked it against a stone wall. Nothing serious. As for the arm, it was muscular pain. She lay down without taking off her dress, tights or bra. She removed her shoes with her feet and fell asleep instantly, with the light still on, a lone shoe on the bed, a jumper strewn on the floor and an empty bottle of water lying on the bedside table. The next day, when she woke up, she decided to go away and think about her life. Her grandmother was happy with this change or attempt at change. She suggested travelling to put things into perspective and Adele agreed. She spent the next two years volunteering in Africa.

At the end of those two years she caught malaria in Côte d'Ivoire and returned to Paris. She had more attacks in the years that followed. Whenever the violent tremors started, always at sunset (which brought an end to all of the romanticism she had associated with that time of day), she would launch into a confused prayer. The chronic malaria for a long time, far longer than her parents had stayed with her.

Then she began to die with more gusto

Adele's grandmother, Anasztázia, who had always been
a keen supporter of charitable causes, began to show her
tiredness: her optimism had gone grey, just as she had.
Anasztázia was irremediably old, wizened and rooted in
her past like a willow tree. She lamented her life, some-
thing she had never been in the habit of doing. She
had always shown great energy, she was a fighter, and
she always had a Bertrand Russell book on her bedside
table which specifically urged her to help other people
for the sake of her own happiness. Anasztázia did not
need such a book: that really was her nature. The book
served only as validation for her way of being in the
world. But the years take a heavy toll on our optimism,
on the things that make us happy, and that is what hap-
pened to Anasztázia. Her kindness, which had always
been her defining characteristic, was exhausted by age
and by memories that made her feel uncomfortable and
tremble under the weight of the cruellest question of

all: would everything have been better if I had chosen differently?

Then she began to die with more gusto: in her death throes, lying in bed and stripped of all autonomy, she sighed continuously for a man she had met on a boat many years earlier. They had had an all-consuming love affair and then he had abandoned her with no explanation. Anasztázia Varga had fallen pregnant as a result of that affair. And as she lay there in bed, waiting to die, she thought only of the past, of that lover who had transformed her into a mother.

**Memories are not only stored in the head,
the entire body, the skin, but also hidden in
cardboard boxes/tidied away in wardrobes**

Adele listened to those sighs of longing for Mathias Popa
so often that one day she made a decision: she would go
and look for that man, her grandfather. Alive or dead. She
went over to the wardrobe, to that cardboard box where
memories are stored, to see if she could find any clues.
These amounted to a card with "Euridice! Euridice!" writ-
ten on the front and the name Mathias Popa on the back
along with another card from an Italian restaurant, with
a simple "I love you" written in permanent ink.

Just the way love should be written:

in permanent ink

Adele Varga picked up the telephone book and quickly
found an address for the publishing house, Euridice!
Euridice!

Wasting no time, she caught a taxi that dropped her off in front of an old building. She went up to the second floor, where she came across a painting: Bruegel's "The Triumph of Death". The legend said something about Dresden. The bookshop was very small, a cubic space with no other geometric pretensions, and was called Humiliated and Insulted. A man with slender legs and a limp on his right one greeted her, in a kind and unintrusive way. Adele liked him, liked his nervous mannerisms. She told him about her grandmother, which he found moving.

Bonifaz Vogel and Mathias Popa

"Please, take a seat," Isaac Dresner said to Adele Varga. "I don't have any good news for you. Would you like something to drink? No? Now look, it may come as a shock to you, but the person you're looking for is dead. I'm so sorry, believe me I am. There was something inoperable in his head. Ultimately, we all have things in our heads, and those things are always an insult to surgery. But there is another story which is more important for you."

Isaac limped slowly to the shelf by the window. If clouds – which are synonymous with lightness – can weigh more than four hundred kilograms, then why should heads – which we know tend to get heavy – not weigh more than clouds?

Adele looked down at Isaac Dresner's foot.

"Rheumatism," he said. "Some days I can hardly walk."

"Would you like some help?"

"There's no need. Here, read this book. It's called *Kokoschka's Doll* and it was written by Mathias Popa."

Adele took the book and leafed through the opening pages.

"The book," Isaac Dresner clarified, "tells the story of Mathias Popa, as well as that of the Varga family. Something that will surely be of interest to you."

"How did he die?"

"Who, Popa?"

"Yes."

"As I said, it was something in his head, I don't know any more than that. The dead tend to end up becoming indistinguishable from one another, even in our own memories. It happens above as well as below ground. In a way, Mathias Popa wrote a book in order to purge his past. He wrote about me, too: he depicted me as an eccentric editor who sought to give life to dead things, to dumbfounded men, open-mouthed and aghast at life. I gained a few centimetres in height and became a sinister Hungarian. Neither of which I have ever been, not even when I lived in Nazi Germany. However, the entire story of the Varga family appears to be true. So true that it is standing here before me. But please, don't cry."

"I'm not crying, it's my allergies."

"It happens with me too. Especially when I think about my mother and my fathers. Yes, I've had two in my life. To be precise, one of my fathers was a son to me. He wasn't my biological father, but then relationships aren't built only from biology. The saddest thing was knowing

that he, Mr Vogel (I began addressing him that way when I was still a child stuck in a cellar), was profoundly sad when he died. In the final years of his life he used to come shopping with me, and he would stand there admiring a lady who used to shop at the same place. We had the same routine as she did: we did our shopping for the rest of the week every Friday. I never understood his fixation with her. If for any reason she didn't appear, Mr Vogel would stand still, looking everywhere with his mouth wide open. He loved that woman, or so it seemed, for it wasn't at all easy to understand what was going on inside that head of his. Tsilia suggested I write some love letters in his name. I don't know if it was because of my prose, but not only did the woman not reply to the letters, she actually died. At least that's what they told me at the supermarket. When Mr Vogel found out he sat in his wicker chair and expired, died, completely still, without bothering anyone. He was like a glass in a bull shop. To this day I cannot look at that chair without having an allergy attack of the kind you are currently experiencing, my dear. I've cleaned up a great deal, but you know how it is with dust mites and pollen."

Isaac Dresner took a cloth and dried Adele's eyes. Then he used his sleeve to wipe his own.

"A month after Mr Vogel expired through his open mouth," Isaac continued, "a gentleman came to my house. He was the son of the countess who had not replied to the cards I sent. He brought two unaddressed envelopes with

him. He said that his mother had not had time to send them, since death is the great enemy of amorous correspondence. One of the letters was for Mr Vogel, the other was for me. I don't recall ever having felt such sadness while reading something."

Isaac Dresner dried his eyes again as he said goodbye to Adele Varga.

Letters from the countess

Mr Bonifaz Vogel,

I read your words with great care. They were like a staircase to me, the easy kind, the ones we go up as if we were going down. I'm far from young, but I can still climb stairs to heaven. On all other occasions I use the lift. Our old age attracts time, time passes us with more intensity, opening up wrinkles as it slides through our bodies. Wrinkles are the wounds of time, and sometimes they are so deep we end up dying of old age. That is why it was with great joy that I read your letter, Mr Vogel. I carry it always in my purse, next to a photograph of my son. It feels very good to climb those stairs, to read those words. Don't be afraid the next time you see me in the supermarket, please talk to me. At this age, with the end of our world so near, our souls must be completely bare when we leave our spent bodies. I also noticed you, with your shocked expression, as if you were seeing the world for the first time, a felt hat upon your head. I feel more alive now knowing that you have noticed me, and I suspect that

you will feel the same thing when you read these words, Mr Vogel. It is other people who bring us to life, especially those who love us. My profile has been blurred for several years now. Your words have restored some of my clarity.

We shall talk soon, Mr Vogel. Your own,
Malgorzata Zajac

Dear Isaac Dresner

I am no shrewd observer, but I understood straight away that you were the author of the letter addressed to me, signed by Bonifaz Vogel. People talk too much in supermarkets. I know who you are and what you are doing. I feel ambivalent about your actions. You have managed to extract that which Mr Vogel could not say, but you had to employ a ruse in order to do so. I have one thing to tell you: though you may seem like a puppet master, the truth is quite different altogether. It was Bonifaz Vogel who made you talk. You know that the soul follows and obeys the body and not the other way around. The soul is a dog, always faithful to the rawer, more bony material. Dogs go after bones, just as our souls do. Just witness what science has to say about how we make decisions. Experiments in this field tell us that, when someone gets up, they begin to move their muscles – an imperceptible act of anticipation – before they take a corresponding decision

in their brain. Our soul is not driving the carriage, rather, it is being carried along by the horses and does little more than comment, like the stone thrown by Spinoza: I am going to fall onto the ground, says the stone. Every stone we throw believes it can choose where it is going to fall, and during its trajectory, which is an entire lifetime, it keeps pointing out its route as if it had chosen it. I fear that you are the most obvious puppet in this love story. Remember that we, the souls, trail behind our bodies, tied to a leash.

In spite of everything, I thank you for the words you have written to me, words which, as I have said, really belong to Bonifaz Vogel. Your role was to extract, from the body of your father (he is your father, isn't he?), a letter that he had already written inside himself. But Bonifaz Vogel's pen writes with ink, not blood.

Best regards, Malgorzata Zajac

Nudged out of the birdcage

The world is far more compact when we are unaware of what is going on around us. It is a portable thing, one we carry with us wherever we go. On the other hand, when it reveals itself to be just around the corner, when it has a landscape, it becomes a place that is difficult to bear. Too big for the birdcage in which we live. All new discoveries are like that, frightful. As she left Isaac's house holding a book, Adele Varga was a bird who had been nudged out of the birdcage. She walked for a while with her arms open wide (like a bird that has just been ejected from its heavenly prison), trying not to think of anything. She used her very last reserves of energy to climb the stairs to her apartment, holding on to the bannister the whole time. Night fell after her exhausting day. She sat down on the sofa, turned on the television and turned it off again, eventually falling asleep. She woke in the middle of the night with a pain in her neck, annoyed with herself for having fallen asleep on the sofa. She drank a glass of juice and lay down in bed.

The following day she rose early and took the Métro to her grandmother's house.

Horizontality: the bed is the final gateway, par excellence

Horizontality is one of the main symptoms of death, a place where everything gets mixed together. Verticality symbolises the exact opposite. That is why we are impressed by the way a flower unfurls as it comes to life and disappointed by pumpkins, melons, snakes and lizards, which spread sleepily over the ground instead of growing upwards like bolder spirits. A tree on its side is dead, not sleeping, and animals experience a taste of their own end when they sleep. Horizontality is the triumph of death; the Universe, though round, is horizontal. The Earth is more or less spherical, but what one sees, when one is looking, is the horizon. Perhaps that is why sex is always so close to death, because it is so essentially horizontal. By joining death to sex, to original sin, Saint Augustine had a glimpse of death being transmitted through D.N.A., the two blending together in bed, which is where we sleep and die with great frequency. Because there is an order in our D.N.A.

261

that says we must die. And it prefers to be communicated horizontally.

Anasztázia was lying in that paradoxically comfortable position, the most comfortable position, the position of death: she was horizontal, in a bed, our final gateway *par excellence*.

Adele entered her grandmother's bedroom, took off her jacket and placed it on the back of the chair. Anasztàzia Varga looked at her granddaughter with her age-worn eyes and told her to sit down. Adele obeyed and held her hand.

"If I am lucky, Adele, I will die in my body and soul at the same time. One of my mother's brothers left this world completely out of sync. His body remained in bed, empty, abandoned. The same happened with the cardinal who used to live on the first floor. He was like a dried-out branch."

Anasztázia was a sleeping beauty who, instead of waiting for an alarm-clock kiss, a morning kiss to wake her, was waiting for a final kiss. She was waiting for Azrael, the most ravishing of princes, he of the lethal kiss, the one that makes you sleep sound for all eternity.

Having such a long past is exhausting. The older we get, the more Evil gets mixed in with Good. A moment of joy, once finished, becomes a drama, while a tragedy, once finished, becomes something joyful. All mixed together. It is very difficult to separate things clearly. It is the opposite of what people say: old age brings no clarity whatsoever. The soul has no equivalent for the glasses we use for our eyes. Memories stay out of focus, and Good and Evil get

mixed together. The passing years are like an electric mixer for morality. All mixed together, like war. Anasztázia dreamed about Eduwa, his tears, his completely honest smile, his shyness, his goodness; she dreamed of unforgettable, joyous, fabulous moments, and suffered because he had suffered. She dreamed of Mathias Popa and of the way their love had changed her life, how from that point onwards she had suffered in life, how she had experienced ecstasy comparable only to the moment when she first held her new-born, how that son had disappointed her every day and how she had loved him every day. Good and Evil mixed together. Like Adele Varga's sunsets, which bring the threat of malaria with them. At that time of day everything is mixed together, shadows and light.

Adele put out the lamp when her grandmother had fallen asleep (in the horizontal position, the most mortal of all positions). She went to the living room, opened her bag and took out the book *Kokoschka's Doll*. She opened it on the first page and read in silence:

CHAPTER 1

Anasztázia Varga, Adele's grandmother, was the daughter of a Hungarian man called Zsigmond Varga, an eccentric millionaire (or perhaps the other way around) who was father to more than fifty children, only eight of them legitimate.

The moment Adele Varga finished reading *Kokoschka's Doll*, she showed up at Isaac Dresner's house

"My husband's coming now," she said. "I'm so sorry about your grandfather dying. Life tends to come to an end, especially with the passing of years. If there's one thing that doesn't resist time, it's life. I knew him, and I remember a bitter but good man. Which isn't surprising when we consider his past and everything he lived through. I felt that I knew him the very first time I met him. Inexplicable thing. Those of us who survived four thousand tonnes of bombs have been left with our memories damaged."

"My foot's a little better today," Isaac said as he entered the room.

Adele smiled and said:

"It's very strange that he, Mathias Popa, wrote this book before I was born and imagined a granddaughter. And it's even more impressive that the granddaughter shares my name. How is it possible?"

"You know, young Varga, I have a deck of cards on this table here. If I were to shuffle the deck and spread it out, you would never expect to see the ace of spades followed by the two of spades, the three of spades, the four of spades, the five of spades, the six of spades, the seven of spades, the eight of spades, the nine of spades, the ten of spades, the jack of spades, the queen of spades, the king of spades. Followed by the ace of diamonds, the two of diamonds—"

"Yes, I get it. It wasn't shuffled."

"It was. That was its initial state. What I said was that you wouldn't expect to find it like that if I were to give you a properly shuffled pack. And yet it is no less likely to come out that way than any other way. Any other way and we would believe it had been shuffled, but not in this configuration. The deck would also be considered unshuffled if, for example, all the aces appeared together, followed by the twos, the threes, the fours, the fives, the sixes, the sevens, the eights, the nines, the tens, the jacks, etc. Some orders are meaningful to us. That's why we wouldn't believe it could simply be the result of chance. We would think that there had been cheating involved. We say it's shuffled when the cards come out in an unclassifiable order. Chance has intervened. But this is only the case because that particular sequence, the one we call well shuffled, means nothing to us. But just because it means nothing to us does not mean that it isn't just as organised,

only according to unknown patterns, as with the first sequence of which we spoke, the one with the ace of spades followed by the two of spades, the three of spades, the four of spades, the five of spades, the—"

"The six, etc. But what does that explain?"

"Sometimes, the deck has an identifiable sequence, one we are able to understand. We say this one is meaningful, what a coincidence, but it's merely something that our mind can explain and connect with other things. The other ones are just as meaningful, but simply too complicated for heads like ours. The girl having the name Adele Varga in the book *Kokoschka's Doll* may be just that: a shuffle that came out in a classifiable sequence. It happens, young Miss Varga. Or perhaps it was your grandmother who convinced your father to give you that lovely name. The name that Popa had used in the book. If that was the case, forget about the decks of cards. It will only confuse things."

Oracular: our lives imitate art

"I sent the book to your grandmother, with a postcard I'd signed myself. I don't think it bothered her to discover that Mathias Popa was her nephew. Or perhaps she didn't find it important. Incest isn't what it once was. She had those memories and didn't want to sully them with such mundane considerations. She must have read the name Popa had given to his hypothetical granddaughter and I suppose she felt that the name used in the novel worked well in real life. She then began to wait for the chance occurrence whereby, faced with death, the girl found love. You know, it is we who imitate art, as Wilde said, not the other way around. A book is composed of archetypes; we humans simply fulfil them. That was what you did, my girl: you did your job by matching the literature. You searched among your grandmother's memories and came here to talk. You read about your great-grandfather's (and your) family and the only thing you can take back to your dying grandmother is this story which, I suspect, she already

knows. Otherwise you wouldn't have the name you do. In any case, your grandmother may not know that Popa is dead. I suspect she wouldn't believe it if you told her. You know, your grandfather is not the Mathias Popa I knew. Or rather, he both is and isn't. I'm certain that the Mathias Popa who forms part of your grandmother's memories is very different from the Mathias Popa I knew. We'd have to join the two together to understand him better.

"We'd have to place layer over layer like my wife does in her paintings. Your grandmother's Mathias Popa is your grandmother's invention, a perfect, mythical Popa, probably far taller. He is an angle; for that is what the world is made of: superimposed angles."

Isaac crossed his legs with some effort.

"It's strange," Adele said. "In the book, I end up falling in love with a musician."

"Nothing is more prophetic than literature."

"To the sound of a song called 'Tears'."

"Oracular."

The question of the thrush

Isaac went to get a bottle of whisky and they raised a glass to the dead. Then they fell asleep on the sofa.

Suddenly, Isaac Dresner woke and grabbed hold of Adele's dress.

"The thrush."

"What about the thrush?"

"I need a whisky. When I was a child, I was just a voice, an underground thing without a body. I forgot about the light of this world, and one day I left that cave and saw the light of day, the one of which Plato speaks. I was inside a bird shop. Canaries that were actually sparrows painted yellow, though the paint had already faded, dappled finches, parrots and parakeets. And outside lay the remains of the world, what remained of it after the war, and a thrush was perched upon the remains of the world. I gave Mr Vogel my hand, and as I was looking at the thrush a soldier came over and talked to me. He was no longer a man, that soldier, he was just one more scrap from the

world, like the leftovers of a meal. You could see clearly in his eyes that inside him there was just an open void with bombs. Do you know, young Varga, that when a man is alive, he knows all the rooms in his house. All of them. He keeps opening door after door until there's only one left. And he thinks to himself, now there's only that one room left. That's why some scientists claim that there is a single thing which explains everything. That is their room. We all know the house we live in, door after door. More whisky? As I was saying, there's just one door left. One day, feeling brave, we make up our mind to open it. Only one room left. Then we come across something unusual: the door doesn't lead to another room, but out onto the street. You see? The street! And that street is full of houses which are, in turn, full of rooms. The other day I opened that door and stood there, still, for several minutes. It was like when I opened the trapdoor and went up into the bird shop and then out onto the street. It was a new world. How had I never seen that? An entire world with trees and everything, a place where one can fly outside cages. My legs began to shake and I even vomited. I slammed the door shut, but a thrush had got in. The same thrush I had seen as a child. This one, the one you can't see."

"I can't see it."

"It's right here." He pointed to his left shoulder. "This is that world. If I ever see this bird I will see the whole landscape. It's the best room a man can wish for, full of

green fields and trees. It was a devastated world when I was a child, but when I opened the door the other day it was a lovely place, like those illustrations you get in Jehovah's Witness pamphlets. The only door we haven't opened in our apartment is the one that leads onto the street. Remember that, young Adele, remember that. Now I'm going to tell you what your grandfather's last words were. Well, not his actual last words, but close enough."

Mathias Popa's last words. Well, not his actual last words, but close enough:

"I hope you like the book," Mathias Popa said. "I am at this very moment walking towards my death. We are all doing that, but I can already see the curve in the road, it has been clearly signalled to me by several doctors. They're saying it's something in my head. It feels heavy, but that's because of some incredible memories. Our heads are filled with ghosts, and neurosurgeons cannot operate on superstitions. They should swap the operating table for a Ouija board. Do you know how I found out I was going to be a father? A few months after leaving Anasztázia, I went looking for her. A bottle of whisky helped me summon up the courage. When I knocked on her door (she wasn't in), a servant appeared, the kind that talks a lot, and she told me what had happened to her: she had fallen in love with an unscrupulous man who had left her pregnant. I didn't know what to do, so I did nothing. I went back to Paris the following year to sit in front of my son's crèche

and watch him play. I would play violin by the railings and passers-by would give me a few coins. I was playing for him, playing everything I knew. It was my way of educating him. I couldn't hug him, because I'm a wild beast. I'm the opposite of Midas, a legend in reverse. That's why I would play all the music my world is built from. I'd play for him and get goose bumps whenever I saw him looking at me, at the drunk violinist. When he went to school I followed him, playing music on the street. I bared my soul as I played, and he listened. But I never hugged him, never touched him. I was like a ghost, the inoperable kind, the kind that does away with us. You'll say there's still time for me to hug him, but I'm afraid. I'm afraid of waiting for him outside his office (he's a lawyer – you abandon a child and look what happens!) and being ignored. I have many spectres, but I'm afraid of discovering that I'm no more than an invisible nobody, immaterial, a ghost, just like the ones that populate me. I don't play for him anymore. I'm afraid of sitting with my violin, or even a saxophone, and watching him walk by without even throwing me a coin. I'm walking to my tomb as we speak, and I have no more melodies to play. I've reached the end and there's no-one around to hear me. The book I give to you is my last sigh. I hope you like it. Until for ever, Mr Dresner. We shall meet in the infinite, like parallel lines."

Everything in oil or acrylic

"Would you like another whisky, young Miss Varga?"

"No. I have to go."

Tsilia was painting and appeared deep in concentration.

Adele Varga took her jacket and left. Isaac Dresner kept looking at her. She was sure-footed, but she was the kind of person who is always unhappy, even when they are laughing.

"Why did you tell her that story?" Tsilia asked.

"I don't know," Isaac said. "I improvised the story because I thought she'd like to hear it. I tried to mythologise him, Popa, just as he did with me, using words he might have used. I don't like to think about the Mathias Popa who was living in Cairo when his son was born, the Mathias Popa who snubbed his son when he was in Paris and discovered that he was going to be a father. I believe that the Popa who sat outside the crèche playing for the son he couldn't hug was also Mathias Popa. He may even

have been a more real version of Mathias Popa. He wasn't immune to sentimentality, the proof being that he knew the story of his own family in great detail, his mother, his grandfather, Anasztázia . . . He may have seemed to be immune to any kind of sentimentality, but I think it was only a question of doors and rooms. He never opened the door onto the street. He uttered many things with mighty sentences but spent his life curled up in a corner. You must understand this more than anyone. You who can see the Eternal, you who can see the world full of ink layers, superimposed angles.

Tsilia looked bored and stopped painting.

"I'm going to sleep," she said.

"The vision of the world isn't just what we see," Isaac said, following her to the bedroom. "It's also what we imagine. Time isn't an arrow from the past to the future, time has many dimensions, like space. It goes forward, it goes backwards, but it also goes in every direction, from left to right and right to left, and vertically, upwards and downwards. The Mathias Popa I described to Adele exists in a vertical timeline, just a bit to the side, to the left maybe, despite not existing on our past/future arrow. So long as we can't see time in all of its dimensions, we can't see anything. Not even with all the angles in your paintings, Tsilia, not even with all those angles."

"My angles are all the angles. Any one of my paintings contains every perspective. Including the fantastic ones,

even the unimaginable ones. Art is made from the unimaginable. The most solid perspectives, the primary ones, act as bases for the other ones, the visible ones. I could explain it all to you, but it's very difficult. That's why I paint: it's the only way I have of showing all the segments of reality and all the segments of fiction (which is far more, infinitely more extensive than reality). All in oil or acrylic. I'm a Jew with wounds, a series of superimposed angles, of different realities on top of one another, or religions all mixed together, so much so that it makes me bleed. I'm a human being trampled by countless overpowering perspectives. Turn off the light when you leave the room."

Miro Korda in Paris (again)

NIETSZCHE SAID THAT WITHOUT MUSIC, LIFE WOULD
BE A MISTAKE. AND CIORAN SAID THAT WITHOUT BACH,
GOD WOULD BE A COMPLETELY SECOND-RATE FIGURE.

He went to the same guesthouse he always stayed in, but
there were no vacancies. He decided to sleep in the train
station to save money, but he was thrown out around mid-
night because the station closed at a certain time. He felt
the cold was too vast. He walked a good few blocks. He
was so tired that he curled up next to a big gate, but a few
minutes after falling asleep he was woken by a lorry trying
to get out. He stood up, disorientated, and walked a few
more blocks. The lights and the cold were ganging up on
him and he began to consider looking for a more expensive
hotel. They would definitely have rooms there. He ended
up finding the entrance to a Métro station, from which a
genuine heat was emanating, and sat down next to the beg-
gars lying there (there were hordes of them). He felt like he

was at a beach resort, though a long way from Cancun. But his situation was far worse than that of the other tourists: he was the only one with no newspapers or cardboard.

The only reason I'm not a vagrant is because I don't have a licence, Korda thought.

He sat there for a few moments, warming up, and fell asleep in that awkward position, with a thread of drool hanging between his head and his chest. When he woke the next morning, he headed to the bar where he was playing that night. Out of sympathy, they gave him a room on the second floor which happened to be free. Korda thanked them and went up the stairs. He entered the bathroom and saw a different, older Miro Korda in the mirror. He combed his eyebrows with his thumbs, in a symmetrical movement.

For three days he played to the best of his abilities, accompanied by a pianist and a double bass player. The pianist was a virtuoso, an Italian so fat he was almost a giant, always wiping the sweat from his brow and face with a white cloth. He smoked endlessly and Korda sensed a great deal of empathy from the moment he met him. The double bass player was a sort of beggar with dark glasses, who drank sparkling water during the intervals and didn't speak to anyone.

"Listen to this, Korda," the pianist said, holding a book. "It was written by Pieter H. Grunvald: 'The piano is not just a theological instrument. For those in the know, it's

possible to turn it into a musical instrument. But it's the first feature, the theological one, which interests me. Regarding this point, I'm not going to go into detail about the black-and-white keys, the Manichaean ebony and ivory, the musical yin and yang, nor the fact that the piano either has a tail like the devil or is vertical like Man (who is merely a devil without a tail). Desmond Morris said that Man is a hairless monkey, while divine Plato said that man was a featherless biped. But the most precise biological/theological definition of Man is that of the imp with no tail.

"'Pirandello says that the soul is a talented pianist while the brain is a piano. And that, he says, taking inspiration from Blavatsky, is why the senile man or the imbecile retains an uncorrupted and perfect soul. A senile man is a pianist playing an out-of-tune or broken piano.

"'That is why Man produces grotesque noises rather than beautiful harmonies. Pirandello affirms that decay, the body's deficiencies, is behind the soul's clear lack of talent. I have my doubts about the pianist. Can the whole pianist (that is, the soul) really be talented?'"

"I couldn't disagree more," Korda said. "In my opinion, such separations of the body and the soul are useful for selling self-help books. For me, the piano and the pianist are the same tune.

"They can't be distinguished from one another; they are not Cartesian objects. So, what number shall we open with?"

The end

Adele sat down at the bar and ordered a Manhattan. She put the cherry in her mouth, and Korda couldn't help but notice: there, sitting in front of him, was a ninth followed by a major seventh. Leaving the pianist with his cigarettes, he stood up, smoothed over his eyebrows with his thumbs and sat down at the bar next to Adele.

Words failed him and he said nothing. She didn't even notice there was a man sitting next to her and continued to drink her cocktail as she thought about her grandmother.

Korda asked her for the time and said:

"I feel like I know you from somewhere. I've got this feeling."

"Sure you do," she said, tired of hearing that. But when she looked at him, she felt the same thing.

"I'm about to play," Korda told her, pointing to the stage with his thumb.

"You're a musician?"

"I am. Want me to play anything special?"

"Can you play a tune called 'Tears'?"

"By Django? You like that one?"

"To be honest, I don't know it. But I feel I must propel fate."

Be that as it may.

AFONSO CRUZ, born in 1971, is the author of more than thirty books, including novels, play scripts, picture books, young adult novellas, and collections of poetry and essays. His books have been translated into twenty languages, and have received many awards, including the European Union Prize for Literature for *Kokoschka's Doll*. He is also a columnist, illustrator and member of the band 'The Soaked Lamb'.

RAHUL BERY is a translator based in Cardiff, Wales. His translations from Portuguese and Spanish have been published in *Granta*, *The White Review*, *Words Without Borders* and the *T.L.S.* His first full-length translation, *Rolling Fields* by David Trueba, was published in 2020. He was translator-in-residence at the British Library from 2018 to 2019.